JENNIFER MONTAGU

BRONZES

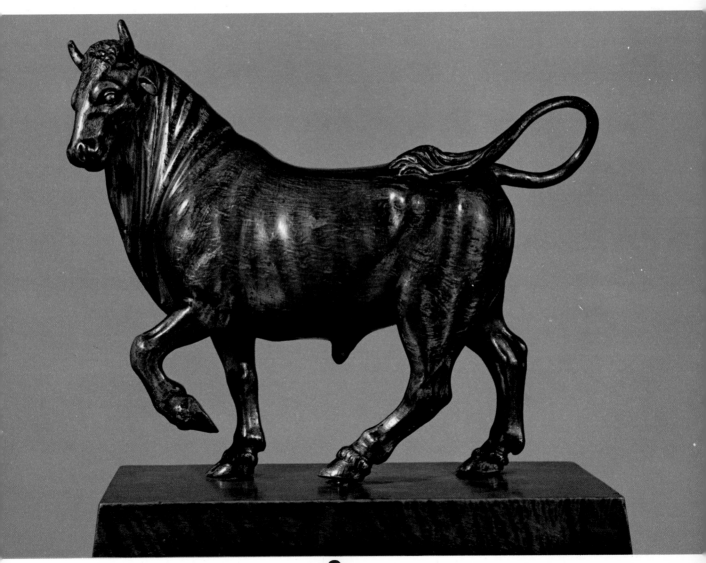

OCTOPUS BOOKS

Acknowledgments

The author wishes to express her gratitude to the many experts in museums and libraries, and particularly to the staff of the Warburg Institute, who have given her so much help and encouragement and have put the results of their researches at her disposal.

The author and publishers wish to thank the following institutions and individuals for permission to reproduce the illustrations of bronzes in their possession mentioned against their names: Victoria and Albert Museum, figures 5, 15, 25, 26, 27, 32, 33, 35, 37, 43, 53, 76, 87, 90, 109; Kunsthistorisches Museum, Vienna, 10, 17, 36, 39, 46, 47, 48, 50, 57, 60, 77, 84, 89, 96, 97, 101–104; Museo Nationale, Florence, 2, 4, 12, 13, 14, 51, 52, 54, 79, 88, 98, 106, 107; Stiftung Preussicher Kulturbesitz, Staatliche Museen, Skulpturenabteilung, Berlin, 11, 24, 44, 65, 71, 75, 95; Ashmolean Museum, Oxford, 19, 31, 38, 63, 64, 117, 119, 128; Wallace Collection, London, 20, 91, 100, 113, 114, 123, 132; Bayerisches Nationalmuseum, Munich, 62, 67, 68, 81, 99, 108, 130; Musée du Louvre, Paris, 22, 93, 112, 122, 131, 136; Musée des Arts Decoratifs, Paris, 118, 135; Skulpturensammlung, Dresden, 1, 70; National Gallery of Art, Washington, D.C. (Samuel H. Kress Collection), 3; Museum of Decorative Art, Copenhagen, 7; Palazzo Vecchio, Florence, 6, 78, 80, 82, 83, 92; Museo e Galleria Nazionale di Capodimonte, Naples, 9; M. Pierre Jeannerat, 16; Philadelphia Museum of Art, 21, 23; Musée Jacquemart-André, 29; Stiftsmuseum Klosterneuburg, 30; Staatliche Antikensammlung, Munich, 40; Metropolitan Museum of Art, New York, 45, 49; Kunstgewerbe-Museum, Berlin, 51; The Frick Collection, New York, 56; Ost. Nationalbibliothek, Vienna, 58; Landesmuseum Joanneum, Graz, 69; British Museum, 72 and endpapers; Herzog Anton Ulrich Museum, Braunschweig, 66; Germanisches Nationalmuseum, Nuremberg, 73; John G. Johnson Collection, Philadelphia, 85; Madame Sommier, 116; The Cleveland Museum of Art (John L. Severance Bequest), 120, 121; The Cleveland Museum of Art (John L. Severance Fund), 115; Bibliothèque Nationale, Paris, 127; Château de Versailles, 134; The Rijksmuseum, Amsterdam, 125; Mallets, Bourdon House, London, 124, 126; Ex-Auriti Collection, 133; Musée Rodin, Paris, 137; Benedict Nicolson Esq, 129; Galleria e Museo Estense, Modena, 41.

The following illustrations were photographed by those mentioned: Victoria and Albert Museum, figures 4, 6, 12, 13, 16, 22, 41, 52, 80, 82, 83, 133; Messrs A. C. Cooper Ltd, 15, 19, 20, 26, 27, 32, 33, 37, 43, 63, 64, 87, 113, 117, 132; Scala, Milan, 2, 14, 51, 54, 79, 92, 106, 107; Anderson, Rome, 8; Alinari, 28, 42, 78, 88, 98; A. J. Wyatt, 21, 23; Bulloz, Paris, 29; Giraudon, Paris, 40, 131; Fräulein Gnamm, 67, 68, 81, 99, 108, 130; V. Oberhammer, 58; Deutsch-Fotothek, Dresden, 70; Monsieur Chuzeville, 86, 93, 112, 136; Wildenstein, 116; Jennifer Montagu, 134; Warburg Institute, London, 18, 34, 94, 105, 111; Kunsthistorisches Museum, Vienna, 30; Archives Photographiques, Paris, 122; Hauptamt für Hochbauwesen, Nuremberg; 74; Soprintendenza alle Gallerie, Naples, 9.

This edition first published 1972 by
OCTOPUS BOOKS LIMITED
59 Grosvenor Street, London W.1

ISBN 7064 0037 2

Preceding page
A bull, imitated from the antique by a follower of Giovanni Bologna

PRODUCED BY MANDARIN PUBLISHERS LIMITED AND PRINTED IN HONG KONG

Contents

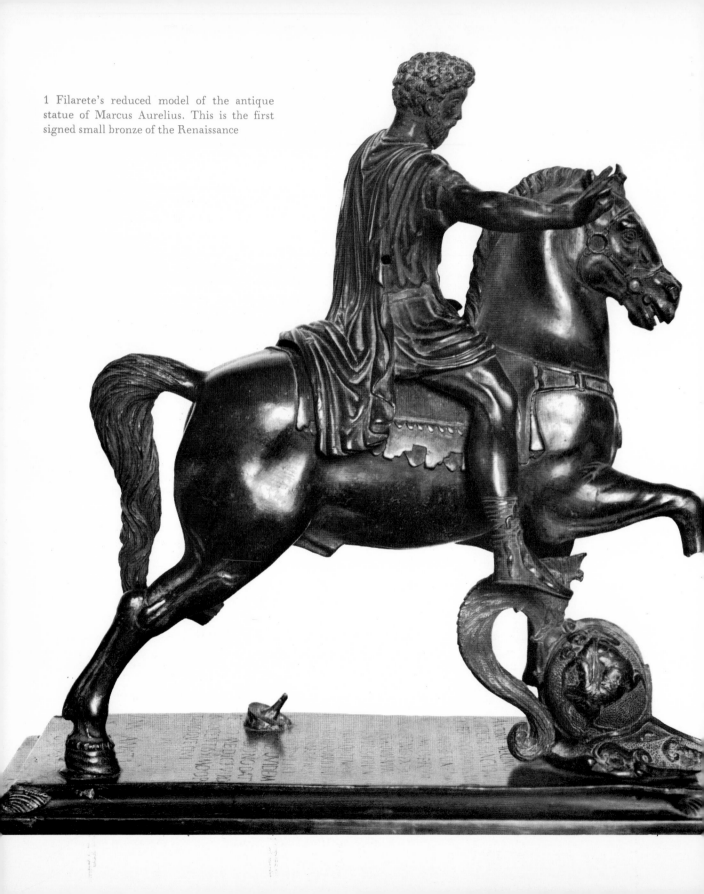

1 Filarete's reduced model of the antique
statue of Marcus Aurelius. This is the first
signed small bronze of the Renaissance

The Art of the Small Bronze

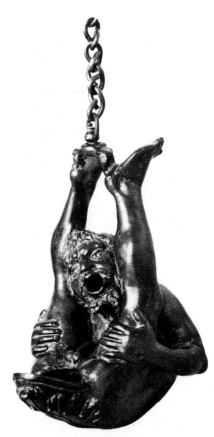

2 A sixteenth-century Paduan hanging oil-lamp

THE SMALL BRONZE STATUETTE, an art which had reached such perfection in classical antiquity only to languish during the Middle Ages, was re-born with the Renaissance, and no other art catches so completely the spirit of that great epoch. Its origin in fifteenth-century Italy is one aspect of that striving for a renewal of classical excellence, whether by a re-creation of art in the spirit of classical antiquity, or by a reproduction of its surviving monuments. Significantly, through all the changes of taste which these statuettes have reflected in succeeding centuries, one subject has remained constant: the reproduction of the great masterpieces of antiquity.

There is a peculiar appropriateness in the fact that the earliest signed and dated small bronze should be just such a reduction: the small *Marcus Aurelius* made by Filarete while he was working on the bronze doors of St Peter's, and dedicated by him to Piero de' Medici in 1465 [figure 1]. True to the Renaissance spirit, this is not a mechanical copy, but varies the proportions and movement of the original, as well as adding the supporting helmet and a touch of polychromy in the violet-blue enamel with gold-painted decoration set in the harness. For these masters, antiquity was not so much a model to be slavishly imitated, as an inspiration and a challenge.

The Humanists, those lovers of classical texts, were well aware of the veneration which small bronzes had received in ancient times. In particular, they were familiar with the praise which Martial and Statius had lavished on a small seated *Hercules*, which had belonged to the collector Novius Vindex. 'I fell deeply in love,' Statius says in his *Silvae*, 'nor, though long I gazed, were my eyes sated with it; such dignity had the work, such majesty, despite its narrow limits. A god was he! . . . Small to the eye, yet a giant to the mind . . . What preciseness of touch, what daring imagination the cunning master had, at once to model an ornament for the table and to conceive in his mind mighty colossal forms!'

This ability to express concepts so far exceeding the

5

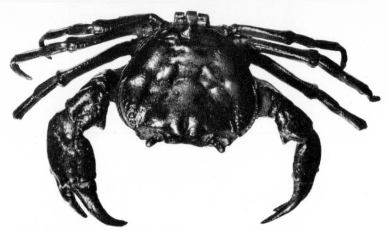

3 A box in the shape of a crab, by Riccio

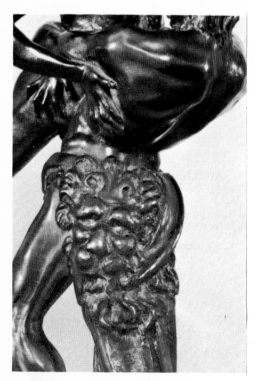

4 Pollaiuolo's broad chiselling on the lion's mask sets it off from the leg of Hercules. A detail of figure 14

5 (*opposite*) A detail of figure 33, satyrs by Riccio. His chiselling gives richness of texture to the bronze, on which the light seems to vibrate as on living flesh

smallness of their material form has remained a part of the fascination of such statuettes. But they have a further appeal, which Statius also recognised, for the *Hercules* had a distinguished provenance, passing from the possession of Alexander the Great through that of Hannibal and Sulla before it came to the ancestors of Vindex. Some of this history may be as suspect as the signature of Lysippus which it bore, but the feeling of direct contact with these great men of the past which contemplation of this little bronze could inspire was quite genuine. A bronze has the intimacy of a household object, something which has been closely involved in the life of its owner, an ornament at the festive table, a treasured adornment of the scholar's desk. This is a quality which bronzes share with the furniture or clothing which survives from past ages, and, with that freedom granted to the minor arts, they can indulge in humour which would appear coarse or heavy-handed on a larger and more august scale, whether it be the broad fantasy of the hanging lamp [figure 2], or the witty play with our reactions of a box in the form of a crab cast from nature [figure 3], whose fierce claws warn away prying fingers. At the same time they can be objects of the highest artistry, fit to rank with the greatest masterpieces. Thus they bridge the division which we so often impose between the 'fine' and the 'applied' arts, combining the best features of both in a unique art form.

Bronze itself is an infinitely variable medium. A molten metal, it will flow into the mould and take on any shape, free from the restrictions imposed by the grain of wood or the limitations enforced by the edges of a block of stone; hollow cast, its lighter forms do not need the same supports as a marble statue, and, less brittle, slender fingers or swinging drapery can be modelled free without fear that they will snap off. But the supreme quality of bronze lies in its surface:

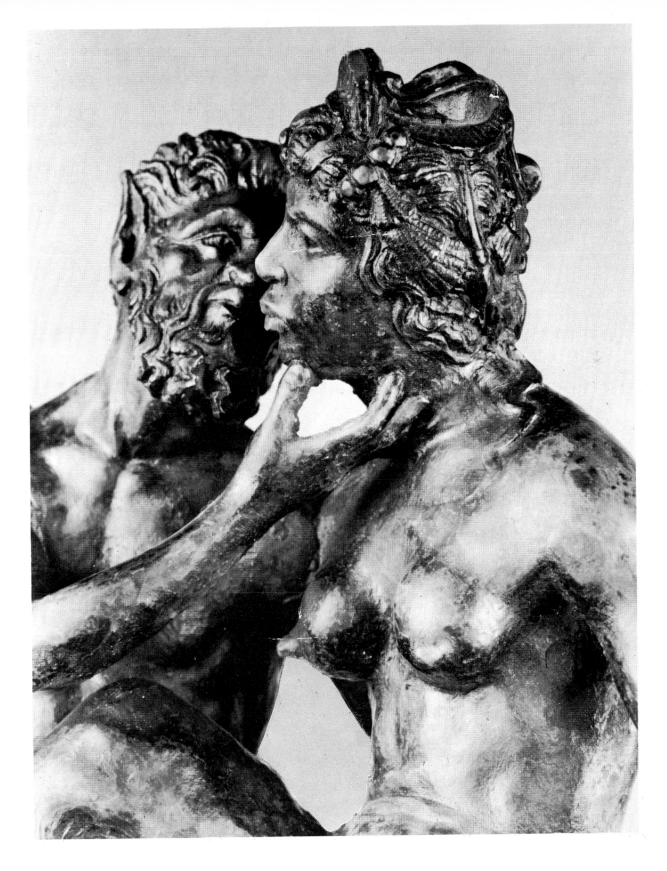

6 Giovanni Bologna's smooth clean chiselling adds to the perfection of his modelling. A detail from his Apollo, seen in its entirety in figure 83

warm and inviting to the touch, it offers the artist an unrivalled gamut of possibilities, from the coarse, brutal quality of a rough cast, to the refinement of a mirror finish. The rough cast surface absorbs the light into itself and takes on a massive weight, whereas the highly polished surface makes the light dance over the modelled forms in a play of kaleidoscopic variations. Between these two extremes lies a range which the skilled artist can exploit with his chisels, scrapers, files, hammers, and punches. Pollaiuolo used the chisel to model the lion-mask in broad facets, a texture which is exciting in itself, and which differentiates the skin of the Nemean lion from the smoother finish of the legs of Hercules [figure 4]. No artist has shown such sensitivity in the handling of bronze as Riccio, whose autograph works display no square inch of dead or uninteresting surface; he could use the broader cuts of his chisel to lead our eyes round the forms, each successive facet opening up a different view of the object, or by his small hammer-strokes set the light vibrating on the metal till it seems to quiver with life and emotion [figure 5]. Quite different was the technique of Giovanni Bologna, whose smooth surfaces are a part of that finished perfection so typical of his subtly modelled bronzes, while the sharp precision of the chiselled hair sets off the softer areas of the flesh [figure 6].

The importance of the finishing of small bronzes exemplifies another feature of the medium which again underlines their position between the 'fine' and the 'applied' arts, and that is the element of craftsmanship which is inherent in the process of their manufacture.

The method of casting generally employed up to the nineteenth century was that of *cire-perdue*, or lost wax. The simplest way of making such a bronze, and that most suitable for small statuettes, would be as follows: A rough core of clay is built up, around a supporting armature if necessary, and the final surface of about a quarter inch depth is modelled on this in wax. To this model the artist fixes thin branches of wax, some of which will eventually provide the channels through which the metal will be poured in, and others the vents through which the gas will escape. This prepared model is then encased in plaster, and thin rods are passed through to hold the clay core steady in the centre when the wax is melted out. This is now done, and a molten alloy of about nine parts copper to one part tin and usually containing some traces of other metals such as lead and zinc (an alloy of one part zinc to about three parts copper would make brass) is

poured down the now hollow pipes. If all goes well, when the plaster mould is broken the cast will appear looking much like figure 7.

Principal hazards in this process are air-bubbles, or pipes which are wrongly placed and so fail to distribute the molten bronze over the whole statue, leaving part of the mould empty. This happened in the casting of the large equestrian statue of *Louis XV* in Bordeaux by Lemoyne, and again in Falconet's *Peter the Great* in Leningrad. The small bronze in figure 7, a reduction of the large *Louis XIV* in Lyon by Desjardins, has the vents and ducts left on to demonstrate how they should be placed to avoid such a disaster, and was bought by the court of Denmark in 1754 at the time when Jacques Saly was preparing a similar monument to Frederik V. Other hazards, such as the caking of the metal in the oven, are vividly described in Benvenuto Cellini's autobiography, where his account of the casting of his over life-sized *Perseus* is equally fascinating to the technician and stirring to the layman.

In the method so far described the original model is lost, so that further reproductions can be made only by taking a mould from the first bronze; this was quite often done, and such copies can usually be recognised because they will be very slightly smaller, owing to the shrinkage of the bronze as it cools, and, unless they are very carefully worked up after casting, the details will be blunted. It is possible to preserve the original model of clay or wood by taking a plaster mould from it, lining this with wax, and pouring a liquid mixture into it which will set and serve as a core. Solid bronzes are rare in any but the smallest or most primitive productions, not only because bronze is very expensive, but also because there is a far greater risk that the solid mass of bronze will crack in cooling. Vasari suggests that, for a small bronze, one could pour wax into a cold, moist mould and swirl it around until a thin, even layer of wax had adhered to the cold surface, then tip the rest out. The successful founding of large works such as Girardon's equestrian *Louis XIV* or Bouchardon's equestrian *Louis XV* were regarded as feats of the greatest technical skill, and were written up by Boffrand and Mariette in lavish books with finely engraved illustrations; but the elaborate procedures needed for these monumental works were not necessary for the smaller statuettes with which we are concerned, which inspired no such literary or visual records.

After any bronze has been cast, one task is inevitable: the

7 A reduced version of Martin Desjardin's equestrian statue of Louis XIV, with the ducts and air-vents still attached to show their correct placing

network of ducts and vents which will have been filled with bronze must be cut away, and the rods which held the core in place within the mould will have to be removed; it may also have been necessary to leave a hole through which the core can be extracted, and this must then be filled in. Almost always there will be at least minor flaws, holes caused by air-bubbles, projections which did not fill, or cracks in the mould through which the metal oozed, and all these will have to be tidied up.

It must be emphasised that no bronze can be left just as it comes from the mould; an 'untouched cast' can be only a relative term. Moreover, the surface of early casts was rough and often caked with chemicals absorbed from the mould, so that the artist would want to smooth this with files and punches, and probably also to sharpen the locks of hair or engrave the details of the eye on the cast bronze.

Finally, the surface must be coloured. The light colour of the fresh bronze may be preserved by varnish, but more often it is patinated, a process which happens automatically in the atmosphere, but which can be speeded and controlled by the use of chemicals. According to the choice of these, the colour can be deep black, liver brown, the slightly reddish 'bronze' colour, varying shades of green, or other more bizarre tints. The means by which such colours were obtained were often closely-guarded secrets, and while Fortnum in 1877 wrote of the use of smoke from slowly-burning green willow twigs or old boots to freshen up a dull surface, washes of chemical solutions were more usual. Sometimes lacquers were used, such as that black lacquer, the flaked surface of which gives Riccio's bronzes so much of their character, or a reddish translucent lacquer applied over the yellow bronze, which was favoured in the workshop of Giovanni Bologna and gives a rich chestnut appearance with golden lights [figure 15].

Gilt bronzes were usually made by fire-gilding, in which a paste of powdered gold in mercury is spread on the bronze, then heated until the mercury is volatized, leaving the gold adhering to the surface. Thin gold leaf hammered onto the bronze was rare in post-antique times apart from gold decoration in damascened work. A cheaper and less durable gilding could be obtained by a mixture of gold-dust in varnish, and the French eighteenth-century gilders often used this method, even when working for their wealthier patrons. Only in the nineteenth century was electroplating perfected, and used for gold, silver, or even bronze which

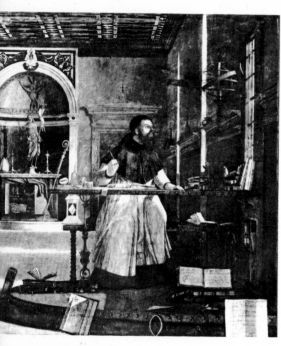

8 St Augustine in his studio, painted by Carpaccio in the Scuola di S Giorgio degli Schiavoni in Venice, as a fifteenth-century Humanist in a room decorated with small bronzes

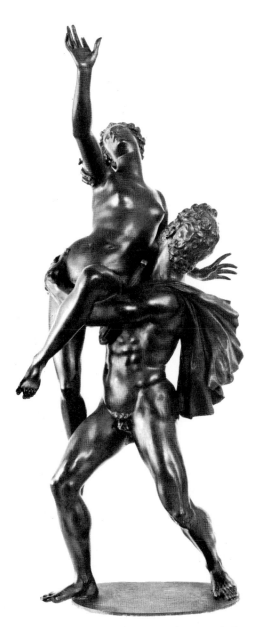

9 The Rape of the Sabines, made entirely by Giovanni Bologna, was sent by him to the Duke of Parma in 1579

could be galvanised onto a cheap mould of gutta-percha to make a quasi-bronze.

Each patina has its own qualities and attractions, and forms an essential part of the bronze's appeal. But patinas are easy to fake, and the age of an object should never be judged by its patina alone. Of course this can work both ways, because quite genuine old bronzes may have been cleaned and their original patina removed. Finally, a thick patina may hide defects of modelling; so in the nineteenth-century bronzes finished with a 'Pompeii' patina were cheaper than those with a 'Herculaneum' one, because, owing to the volcanic ash in Pompeii, the former had a thicker patina and therefore could dispense with that careful chiselling which was always one of the most time-consuming and expensive processes in their manufacture, and more than ever so when skilled hand-workers were at a premium.

An art like the small bronze, so dependent on the slightest nuances of the artist's handling, can be fully appreciated only in the intimacy of a private house [figure 8], where we can hold the statuette in our hand, feel the subtlety of its surface, and turn it around to watch the interplay of its shapes and the movement of light and shade on its modelling. Immobile in a glass case, it becomes as lifeless as a stuffed bird; restricted to the single view and limited tonal range of a photograph it yields but a pale reflection of its beauty.

So we are constantly reminded of those who once owned these bronzes, whose tastes and artistic understanding did so much to determine the direction the artist should follow. The relation between artist and patron is usually a two-way affair, and from the surviving works of art we can postulate something of the character of the man for whom it was made, as well as of the man who made it. Designing an object for private enjoyment, the sculptor could use this medium to express ideas which might prove too sophisticated for the general public. On the one hand this might be an essay in the classical style too closely dependent on antique remains to satisfy any but the most devoted humanist; on the other, it might be a daring experiment in complex formal rhythms; is it just chance that Giovanni Bologna's most sophisticated work should have appeared first as a small bronze [figure 9]? In either case the artist must have been sure of a cultivated and sympathetic patron, sharing his enthusiasm and aware of the problems and challenges of his craft. It was during periods of such enlightened patronage that the small bronze reached its highest development.

11

10 Below this group of Bellerophon taming
Pegasus is the inscription in Latin: BERTOLDO
MODELLED ME. ADRIANO CAST ME

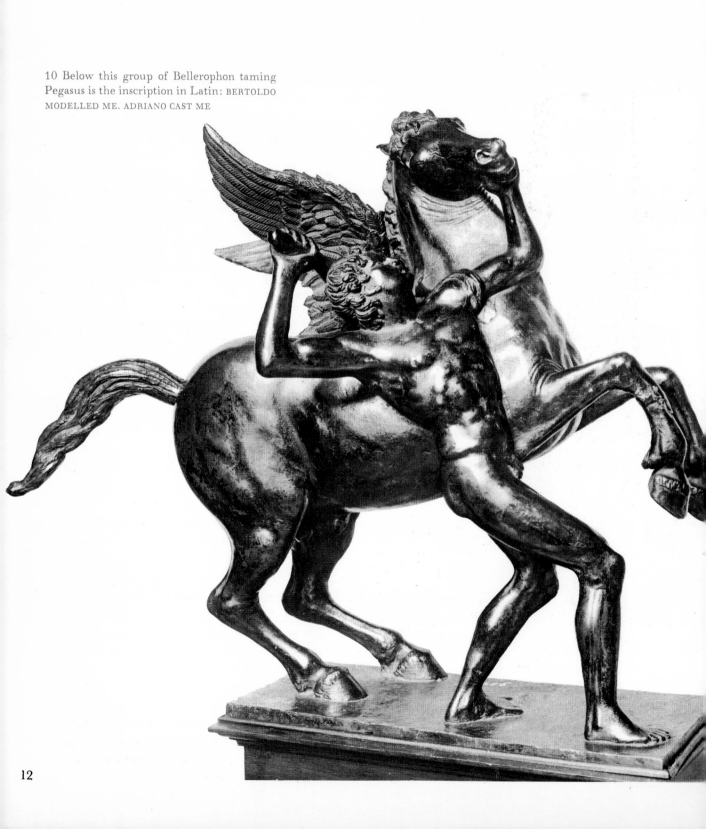

Renaissance Italy

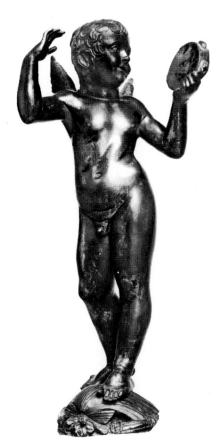

11 Laughing boy with a tambourine, by Donatello. It was one of the *putti* made in 1429 for the font in Siena

OF ALL THE CHURCHES in Florence the Baptistry, dedicated to the patron saint of the city, was the one in which the Florentines took the greatest pride, so the competition of 1401 for the second pair of bronze doors was an event of considerable importance, and the wealthy merchants' guild, the Calimala, was prepared to commission the best sculptor in Italy. The prize went to Lorenzo Ghiberti, and for the next fifty-two years he was to work on the second and third pairs of doors. In 1416 the city council, influenced no doubt by the prestige of these doors, permitted the major guilds to erect bronze, instead of stone, statues in the niches of the guild church of Or-San-Michele. Since a bronze statue cost about ten times as much as a stone one of equal size, but was more durable and certainly more ostentatious, the larger guilds could not afford to fail in this conspicuous proof of their wealth and devotion.

The first Baptistry doors had been modelled in 1330 by Andrea Pisano, and experts from Venice had cast them; perhaps for this reason they had had little effect on other Florentine sculptors. But the second and third doors, the large bronze statues for Or-San-Michele, and other works undertaken by Ghiberti's studio, provided a school of bronze-working for the young artists of Florence for over half a century.

One sculptor who spent some years working on Ghiberti's doors was Donato di Nicolo di Betto Bardi, called Donatello. A bolder innovator than Ghiberti, and less tied to the craft traditions of the goldsmith's trade, he was the first artist since antiquity to create an independent nude statue in the round (his large bronze *David*) and it is not surprising that the first small bronzes in the antique tradition should have come from his workshop. These are various small *putti* made in imitation of such works by Donatello himself as the dancing *Putto* in Berlin [figure 11]. This bronze hardly fits into our study, since it was originally part of a much larger work, the font for the Baptistry in Siena. In 1429 Donatello was paid for the wax to make 'certain nude infants' (in fact

13

three, three more being supplied later by Turini), and it is one of these, stolen during the eighteenth century, which is now in Berlin. However, this little figure has all the qualities of an independent statuette: a multiplicity of views emphasised by its turning movement, a self-contained form which has no need of setting or support, and a mastery of surface treatment, not over-elaborate, but sufficient to differentiate the textures of skin, hair and feathered wings.

Yet no really independent statuettes have been convincingly attributed to Donatello himself. His interests lay in a different direction, and part of the extraordinary quality of his sculpture is in the boldness of its rough-blocked surfaces, so different from the meticulous finish of a Ghiberti; these show up with great force and clarity at a distance, but would scarcely become a domestic statuette. Nor should we overlook Pomponius Gauricus's statement that Donatello had no knowledge of casting, a fact which would undoubtedly have influenced him to leave such minor works to the craftsmen in his studio. Further, we must note that the fashion for small bronzes seems to have appeared only in the latter half of the fifteenth century; it is always difficult to trace such currents of fashion, and almost impossible to explain them fully, or to say whether the absence of earlier statuettes was an effect or a cause; nevertheless, the fact remains that it is to the artists of the next generation that we must look for the real development of this art.

Antonio Pollaiuolo, a later graduate of the Ghiberti workshop, being trained in all probability by Lorenzo's son, Vittorio, has been credited with several statuettes. Of these attributions, the most firmly based is the group of *Hercules and Antaeus* [figure 14], which appears in the Medici inventory of 1495. It resembles in composition the little painted panel, formerly in the Uffizi and recently rediscovered in America, and the technique, with so much of the working done with chisels in the cold bronze, reminds us of Pollaiuolo's tomb of Sixtus IV. From this it should not be assumed that the work is either a simple translation of a two-dimensional design, or of incompetent workmanship. Pollaiuolo took advantage of the three dimensions at his disposal to play a series of variations on the triangular theme set by the shape of the base; he used the sense of weight in the solid substance to impart an almost unbearable tension to the two figures, straining away from the vice-like grip at the waist; he understood the possibilities which his medium gives to create violent forms free from the restraint which a

12 The head of Antaeus from figure 14. The force of his expression is best seen from above and can be admired in a small bronze where it would be invisible in a large statue

larger scale would demand; he exploited every view, including that from above [figure 12], and even the imperfections of the casting have been turned to advantage by the subtlety and variety of his extensive re-working.

In complete contrast to this group stands the classic balance of *Bellerophon Taming Pegasus*, by Donatello's assistant, Bertoldo di Giovanni [figure 10]. Ultimately this is derived from the antique *Horse-Tamers* of Monte Cavallo in Rome, believed at that time to be by Pheidias and Praxiteles, but it has been treated almost like a relief. Bellerophon's legs anchor the winged horse to the earth, and his body leans back in harmony with the rising movement of his steed; the same feeling of control informs the broadly stylised masses of the modelling, with its restricted linear detailing. This masterpiece was seen by Marcantonio Michiel in the sixteenth century in the house of Alessandro Capello in Padua; below its base is the inscription 'EXPRESSIT ME BERTHOLDUS CONFLAVIT HADRIANUS', and from the fact that Adriano Fiorentino left his native city in 1486, we can date the group to the early 1480s.

There are no marble sculptures attributed to Bertoldo, and he appears to have been the first artist to devote his life primarily to small bronze statuettes, reliefs and medals. Such specialization was rare in the Renaissance, though few artists aspired to the mastery of so many arts and sciences as Leonardo da Vinci. Beside one of his vivid sketches of horses for the *Battle of Anghiari* of 1505 he wrote: 'make a little one in wax about four inches long'; such a wax must have been the origin of the bronze *Horse and Rider* in Budapest and the *Horse* in the Jeannerat collection [figure 16]; it would have clarified his experiments in complex twisting movement for the horses in this *Battle* or the slightly later studies for *St George and the Dragon*, and later come into the hands of some admiring collector. Leonardo was intrigued by technique, as much of mechanical construction as of animal movement, and he studied the problems of bronze-founding in order to cast his *Trivulzio* monument; but the slightly flaccid modelling of these bronzes suggests that they are reproductions of the sixteenth century, made to record a model made in a less durable medium.

Although Bertoldo appears to have been the only Florentine artist of any importance to have regarded small bronzes as more than a by-product of his other activity, there must have been makers of less worthy bronze objects such as the Master Sculptors who sang in a carnival song:

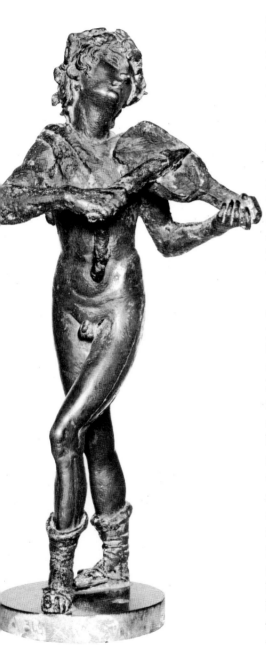

13 Bertoldo's unfinished figure of Apollo was probably abandoned because of the many faults in the casting

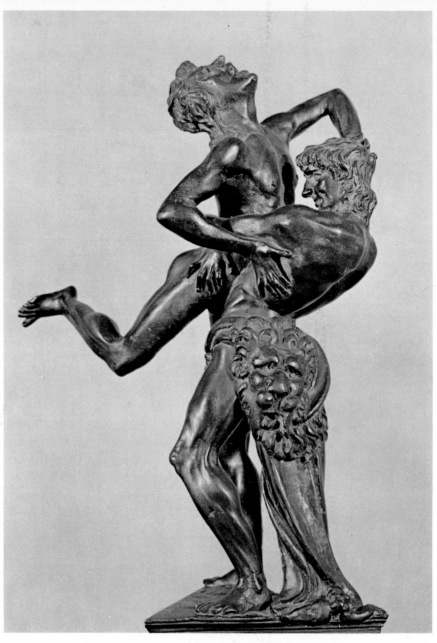

14 The old subject of Hercules and Antaeus was interpreted by Antonio Pollaiuolo with a new vigour and tension

Who would give himself the pleasure
Of some pretty little figure
Fit to put above his bed-stead
Or to stand upon a pedestal,
There's no room that would not profit
From a figure of our making.

They go on to boast of the secrets of casting which they have mastered, and from our knowledge of the carnival atmosphere, we may imagine that the figures they chose to put above a bed were likely to be fairly licentious in character. But

in Northern Italy we find several artists of some distinction whose fame rests almost exclusively on their very serious work as makers of bronze statuettes, to which they brought a new standard of technical perfection.

Padua had a university in which humanist studies played an important part, and from the devoted students of antiquity, so we imagine, came the demand for small bronzes in the antique taste. We visualise such humanists sitting like Carpaccio's *St Augustine* [figure 8] in a study lined with books and little statuettes; in particular, we expect them to have a bronze inkwell. So firm is this link in the popular imagination that it appeared inconceivable that Petrarch, the

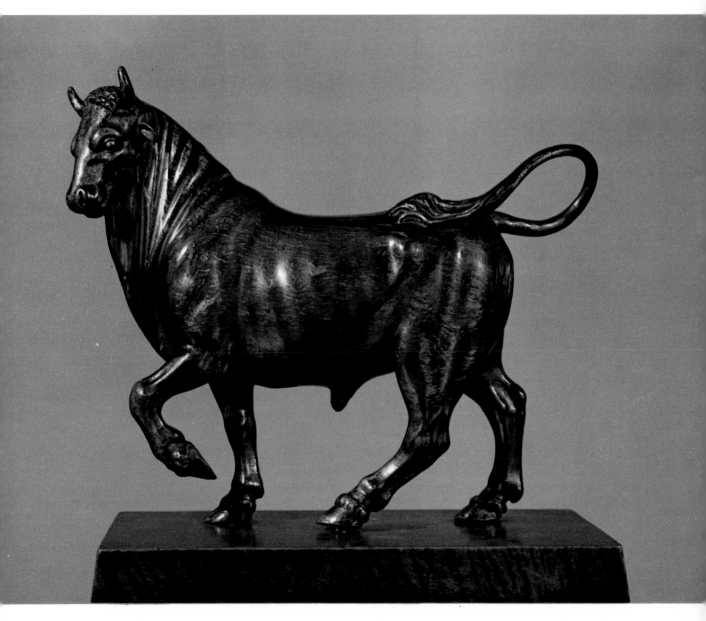

15 A bull, imitated from the antique by a follower of Giovanni Bologna, with the translucent red varnish much used in this studio

fourteenth-century poet and one of the first exponents of humanist thought, should not have owned one of these essential properties, and in the last century a blatantly sixteenth-century model was labelled as Petrarch's, and copies sold to his devotees. The enterprising merchant who thought to double its value by claiming that it is was made by Cellini must have been stronger on stylistic appreciation than on history. But the underlying truth remains: humanist scholars did sometimes interest themselves in the art and craft of the sculptor, and they did provide a market for the copies of antique statuettes and small bronzes *all'antica* which flowed from the Paduan workshops.

Inevitably, when bronzes were being produced in imitation of the antique, confusions sometimes occurred. The sixteenth-century collector does not always seem to have considered the distinction between a genuine antique and a modern copy as of very great importance, and many inventories of the time do not specify whether a particular item was an original antique or not, any more than they usually give the names of modern artists. Deliberate forgeries were not infrequent, but in many other cases perfectly innocent pieces made in the antique spirit came to be mistaken by later generations for the real thing. In 1663 Chauveau engraved as an antique [figure 18] a sixteenth-century bronze urn now in the Untermyer Collection in New York; in the lower left corner is a lamp like figure 17 which, with the urn and other lamps such as figure 2, reappears in Montfaucon's great compendium of 1719, *L'Antiquité Expliquée*.

Apart from a home market avid for, and appreciative of, such works, the industry required a tradition of bronze founding. Here again a major undertaking formed the school in which young men could learn their trade, and the Paduan bell-founders who cast Donatello's equestrian monument to Gattamelata and his statues for the high altar in the Santo must have initiated a number of artists into the technique of bronze sculpture.

It may have been Donatello who trained Bartolomeo Bellano; at all events, whether he went there to assist Donatello or not, he was in Florence in 1468, and it is from Donatello's large bronze *David* that his statuette derives [figure 21]. The best of several versions, that in Philadelphia, has a pastoral scene of David with his sheep in relief under the base [figure 23], a unique feature which testifies to the intimate private quality of this statuette, which could include this secret scene to be viewed only by its owner and his

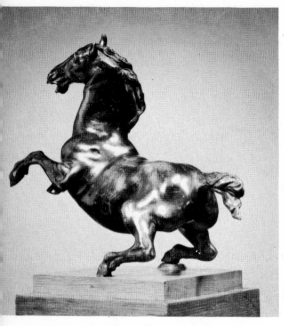

16 Leonardo da Vinci sometimes made wax models to clarify a movement for his painting, and this rearing horse must have been cast after such a model

17 A lamp in the antique manner, made in Padua in the sixteenth century

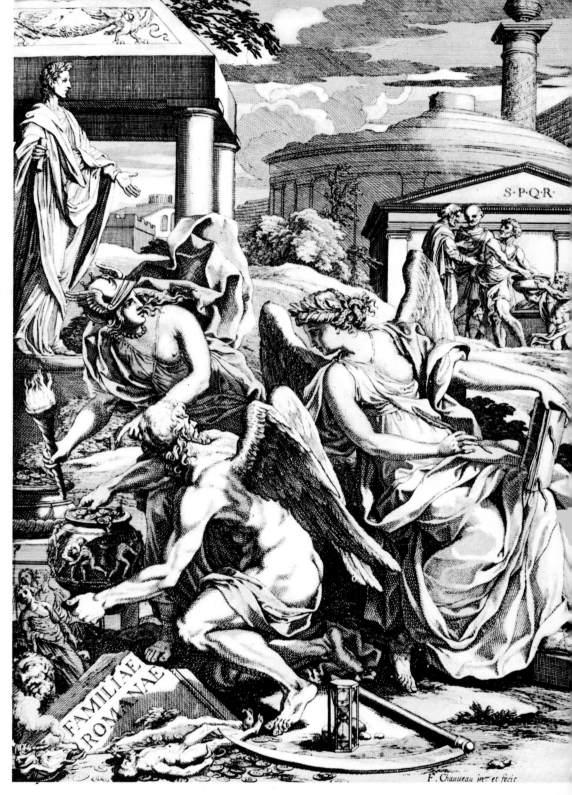

18 A lamp like that in figure 17 was engraved amongst the excavated antiques in François Chauveau's frontispiece for Charles Patin's *Familiae Romanae* of 1663

friends. But this little scene also demonstrates Bellano's love of narrative, with the same rather naive story-telling which enlivens his reliefs in the choir of the Santo. He won that commission in 1485 against the competition of Bertoldo, and the differences in their approaches are well brought out by their two versions of *St Jerome*. Bertoldo's saint [figure 24] is a study in near-naked anatomy and carefully balanced movement, mortifying his flesh with a stone as he gazes at a crucifix, now missing. Bellano has chosen a story full of human appeal and potential humour, of how the saint extracted a thorn from a lion's paw [figure 22]; his angular drapery exploits the highlights and shadows on the polished bronze, and, for all its charm and miniature scale (10 inches high as against Bertoldo's 11½ inches), it attains a massive weight and dignity from the heavy volumes of the drapery.

Among the most intriguing late fifteenth-century bronzes are the *Mountains of Hell* [figure 25]. Hollow cast, they were to be placed on top of incense burners or braziers, and the smoke would have risen through the pierced mouths of the figures to give a vivid representation of the underworld as described by Ovid, from which Hercules (missing in this example), is delivering Alcestis. Five of these are known, and one in the Victoria and Albert Museum has been attributed to Bellano himself, while figure 25, from the same collection, is a workshop production.

From other Paduan workshops must have come the numerous monsters derived from an antique type popularised in the engravings of Mantegna. Some are ridden by Neptune, and many are adapted to some utilitarian function [figure 32], and all were at one time given to an anonymous 'Master of the Dragons' until the signature of Severo da Ravenna was found on one, whereupon they were all transferred to that artist. Yet in their conception of form, their modelling, and their selection and finishing of details, they clearly reveal the work of several different personalities. Indeed common sense would suggest that, given a number of workshops operating in Padua, so obviously popular a model would be unlikely to remain the property of one artist.

There were of course no laws of copyright. Models were passed from one workshop to another, bought and sold and reproduced in various media, as we learn from the fascinating

21 David with the head of Goliath, by Bartolomeo Bellano; the support is modern

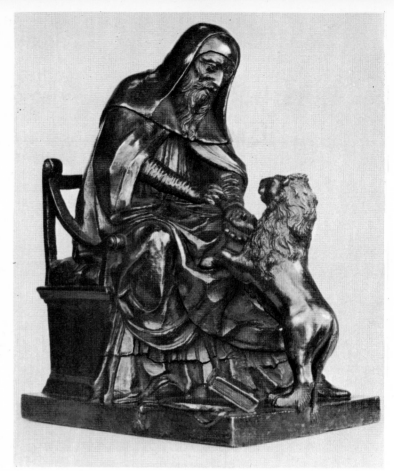

22 St Jerome extracting a thorn from the lion's paw, by Bartolomeo Bellano, a subject which tells a story with a formal treatment of mass and light quite opposed to that of Bertoldo

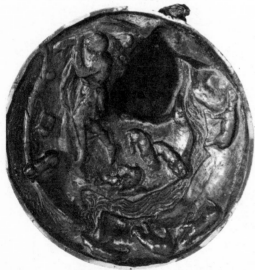

23 This scene of David with his flocks, modelled in relief under the base of figure 21, could have been seen only when the bronze was picked up and handled by its owner

accounts of a trial for the theft of some models from the son and heir of Guglielmo della Porta. The date is some time later than our period; the trial was held in Rome in 1609 for a theft which had occurred some thirty years previously, but it shows how during those thirty years these models had entered the workshops of many different sculptors and goldsmiths, and serves as a reminder that the crime lay not in this unauthorised copying, but only in the theft of the originals. In much the same way top-selling models must have been common to several workshops in Padua, and until some research has been done on the number of these producing bronzes, and into the processes and economics of marketing their products, such terms as 'school of Riccio', 'after Riccio', and 'Paduan sixteenth century' applied to different versions of the same model can be no more than indications of the quality of a bronze. Moreover, just as a Renaissance artist would copy an antique for his patron with no fraudulent

intention, so later artists would imitate bronzes such as the satyrs so popular in fifteenth-century Padua, giving them something of the flavour of their own periods, but not enough to prevent later collectors from attaching to them the optimistic label of 'Riccio'.

Andrea Briosco, known as Riccio because of his curly hair, made in his small bronzes some of the finest sculpture of the Renaissance. But perhaps his most famous work is the large *Paschal Candlestick* of 1515 in the Santo at Padua

24 (*right*) St Jerome in prayer by Giovanni Bertoldo, a bronze designed to display his anatomical knowledge and formal sensitivity

25 (*below*) A Paduan fifteenth-century cover for a brazier or perfume-burner in the form of the Rock of Hell: the fumes would escape through the pierced mouths of the figures

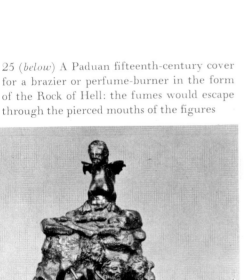

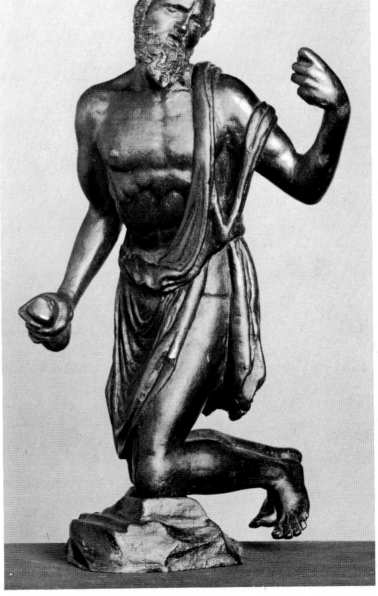

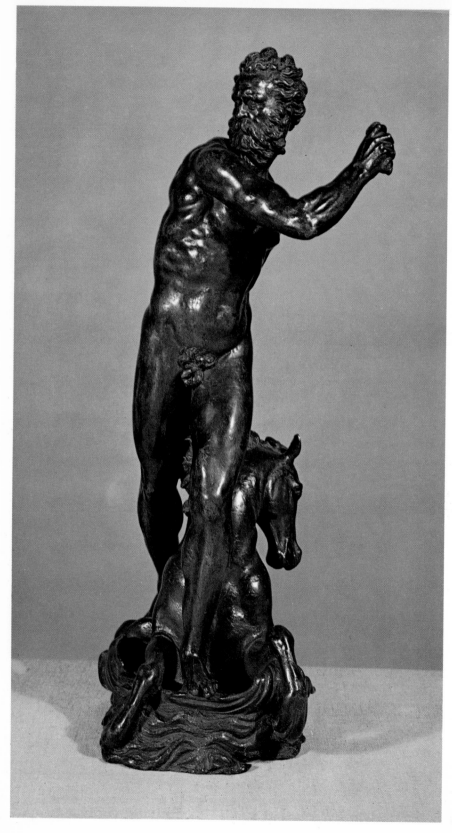

26 Alessandro Vittoria's far more vital interpretation of the same subject as figure 27

27 Neptune commanding the waves, from the school of Sansovino

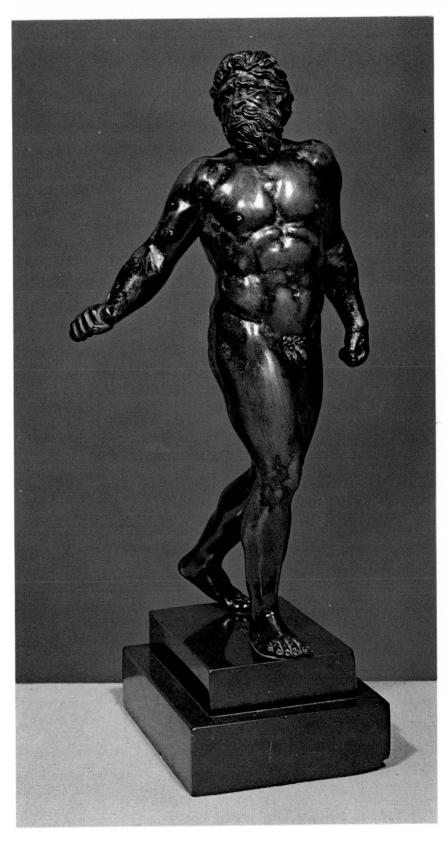

28 The great Paschal candlestick by Riccio the Basilica di Sant' Antonio in Padua

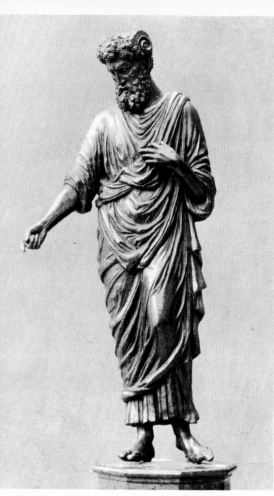

29 Moses striking water from a rock in the desert was used by Riccio for a fountain in a monastery in Padua, where he appears in classical garb with the horns of Jupiter Ammon

[figure 28]; the putti, satyrs and relief scenes which cover its 12½ feet, together with three documented sets of bronze reliefs, provide the evidence for the attribution of most of the independent small bronzes given to him.

For him, as for the Paduan humanists, such as Leone, who commissioned the Santo candlestick, the Christian religion was visualised in terms of pagan sacrifices and classical drapery; of Riccio it might be said, as Reynolds said of Poussin, that he was 'naturalised in antiquity', and into his world the legendary beings of mythology fitted as of right, and thrived in perfect harmony with the togaed protagonists of the New Testament scenes. The traditional horns of *Moses* [figure 29] are those of Jupiter Ammon, and he struck the water from the rock into a basin in the monastery of S Giustina with all the *gravitas* of a Roman orator.

It is another, frankly pagan, side of antiquity which Riccio recaptured in his many satyrs, some holding inkwells or candle-sockets, others, like the couple in the Victoria and Albert Museum [figure 33], symbolising the basic urges of nature. There is neither shame nor coarseness in his art, but a vitality which glows from the hammered metal and the rough surface of the black lacquer.

His only documented small bronze is a 'nude of bronze who carries a vase on his shoulder and walks', which Marcantonio Michiel saw in the house of Marco Mantova Benavides and recorded as 'by the hand of Andrea Rizzo'. This must have been the figure now in Berlin, or the other version in Klosterneuburg [figure 30] and, while it may have been intended as a design for a fountain figure, the sixteenth-century collector must have valued it for the grace of its movement, a preoccupation which it shares with other bronzes of the period such as figure 19.

This too is part of the antique tradition which Riccio had absorbed, and formally his statuettes have that quiet dignity and changeless perfection which is what we mean by 'classic'. Another, more arcadian, side of his classicism is seen in the lovely *Faun* [figure 31]. Of a similar high quality is his *Shouting Horseman*; that in the Victoria and Albert Museum [figure 35] is the only version in which the warrior is seated on a horse of Riccio's own invention, whose nervous head and coiled-spring curves carry the high tension down to the last curl of the tail-ribbon.

It was the unique achievement of Riccio's art to recreate the ideal world of antiquity in sculptures which were never exact copies of the antique. But around the turn of the

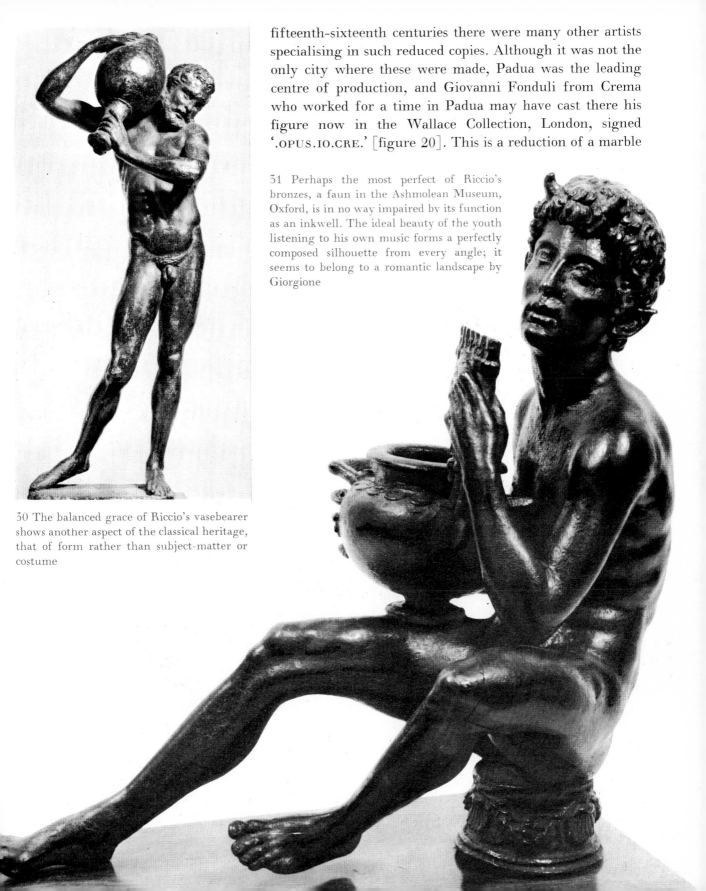

fifteenth-sixteenth centuries there were many other artists specialising in such reduced copies. Although it was not the only city where these were made, Padua was the leading centre of production, and Giovanni Fonduli from Crema who worked for a time in Padua may have cast there his figure now in the Wallace Collection, London, signed '.OPUS.IO.CRE.' [figure 20]. This is a reduction of a marble

31 Perhaps the most perfect of Riccio's bronzes, a faun in the Ashmolean Museum, Oxford, is in no way impaired by its function as an inkwell. The ideal beauty of the youth listening to his own music forms a perfectly composed silhouette from every angle; it seems to belong to a romantic landscape by Giorgione

30 The balanced grace of Riccio's vasebearer shows another aspect of the classical heritage, that of form rather than subject-matter or costume

33 (*opposite*) The surface of the bronze of Riccio's satyr and satyress matches the sensuous warmth of the subject

nymph in the Uffizi, and although it was a popular model in the Renaissance, no other version has quite this perfection of finish. Giovanni Fonduli was the son of a goldsmith, and this education may have inspired the gilding on the drapery to which a coat of varnish has given a rich red tone; that he was familiar with the style of Riccio can be seen from the elaborate coiffure and the decorated throne with which he has replaced the rock of the antique.

Partial gilding such as we see here is often found on antique bronzes, though usually as a symbol of divinity, and, although the symbolism was forgotten, similar gilding on a Renaissance statuette was dictated more by a desire for

32 A Paduan sixteenth-century monster, derived ultimately from the antique, through the intermediary of the sea-monsters in Mantegna's engravings

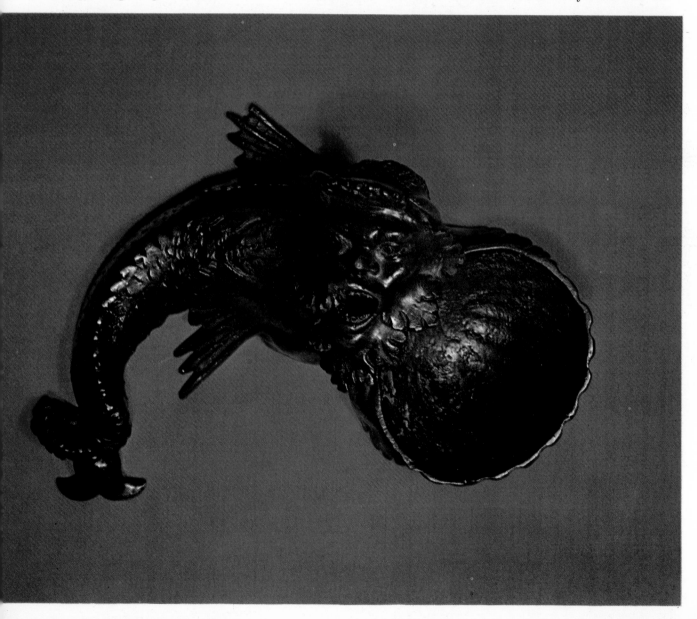

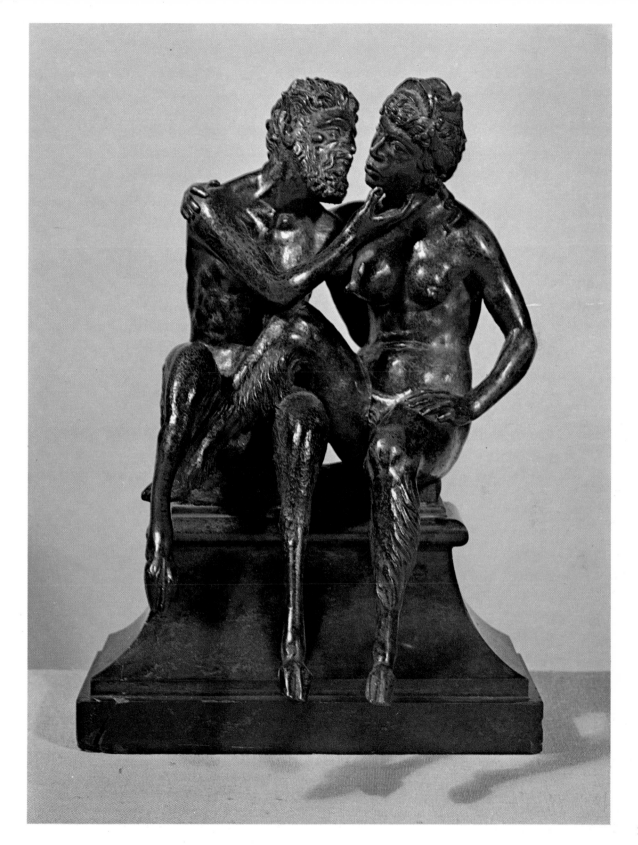

archaeological exactitude than aesthetic fancy. It is often found on the bronzes of Pier Jacopo Alari-Bonacolsi, whose work in restoring antiques and making small bronze copies earned him the surname of Antico, and the patronage of the court of Mantua. One of the most elaborate of these is the recently discovered *Meleager* ·[figure 37], a copy of an antique marble burnt in the fire in the Uffizi in 1762 [figure 34]. Not only the gilt hair, cloak and sandals and the inset silver eyes, but also the smooth surface lacquered to mirror brightness by a brown-black varnish, are symptomatic of the connoisseur-collector, a class which in the Renaissance was as appreciative of a fine patina as had been its counterpart in late antiquity.

The history of the *Meleager* is quite unknown. However the *Hercules and Antaeus* [figure 36] can be traced from Antico's letter of April 1519, where he offered Isabella d'Este a small bronze after 'a Hercules who slays Antaeus, the most beautiful antique there is'. This could be cast by Gian Marco Cavalli from the bronze by Antico in the collection of Bishop Lodovico Gonzaga for fifty ducats. This bronze in Vienna is inscribed below the base 'D(omina) ISABELLA M(antua)E MAR(chionessa)', and it appeared in her inventory as well as that of Vincenzo II of 1627, before passing, perhaps via the collection of Charles I of England, to the court at Vienna, where it appears in the Archduke Leopold Wilhelm's inventory of 1659.

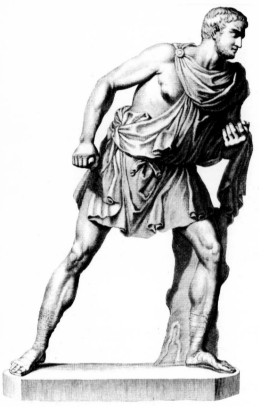

34 An engraving of the marble statue from which Antico copied his Meleager. From Gori's *Museum Florentinum*, Florence 1737

35 In this shouting horseman Riccio combined a richness of detail with the tension of clear lines and planes

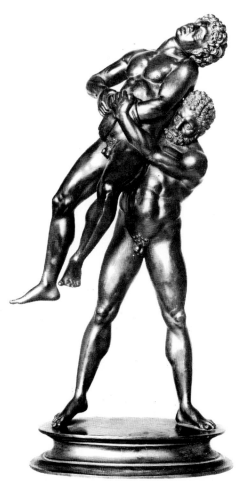

36 Hercules and Antaeus, copied by Antico from an antique marble

From this cold and lifeless classicism of Antico, so different from the energetic treatment of the same subject by Pollaiuolo [figure 14], we can turn back to Padua, to where Mantegna could paint even his religious subjects like antique reliefs, and where St John the Baptist could be draped in a toga which falls into the sharp folds Mantegna also favoured [figure 38]. True, the fur visible at the edges shows that this toga is made of goat-skin, and the asceticism of the saint is evident in his thin, bony limbs, but his pose speaks more of Roman dignity than of Christian ecstasy. This may well be by Severo da Ravenna, so close is its resemblance to the signed marble *Baptist* in the Santo, nor would its skilled translation into light-reflecting metal so as to take full advantage of the varied texture of curly hair, angular drapery and sinewy flesh, exclude this artist, whom his friend Gauricus described as proficient in so many media.

As in North Italian painting, the hard, taut style of Mantegna gave way to the softer, more flaccid manner of a Palma Vecchio, so in sculpture Antonio Lombardo's bronze bust of a girl [figure 41] introduces the full, rounded forms and vague sentimental expression so frequent in Venetian painting of the early sixteenth century, while demonstrating more obviously than any canvas the underlying classicism of these figures. His brother Tullio may have been responsible for the so-called *Eve* in Vienna [figure 39], cast without her arms in imitation, either fraudulent or innocent, of such broken antiques as the little *Maiden of Beroa* [figure 40]. This particular bronze cannot have been known to Tullio, nor is it really fair to set his statuette against one of the most beautiful small bronzes of all time, but the comparison brings out the Polycleitan character of Venetian classicism, in contrast to the harder, Roman quality of most other Renaissance schools.

A patina of the silver-green of an olive leaf on a body of exquisite balance and refined proportions must have made the *Hercules* in the Ashmolean Museum [figure 19] into the pride of any humanist's collection. Long attributed to the Paduan goldsmith Francesco da Sant' Agata, on the strength of a signed boxwood statuette in a similar pose, it has recently been transferred by J. Pope-Hennessy to Vittorio Gambello, called Camelio. The known reliefs and medals by Camelio have much in common with the *Hercules*, but less with the other bronzes assembled round it, which form no more coherent a group under the name of Camelio than they did under that of Sant' Agata.

38 St John the Baptist, a Paduan bronze probably made by Severo da Ravenna

Figure 44, attributed to Maffeo Olivieri, marks another shadowy artist. Born in Brescia in 1485, Maffeo signed the pair of large bronze candlesticks presented by the Bishop of Brescia to St Mark's on 24 December 1527. We do not know whether these were made in Venice or Brescia, and while the *Tubalcain* is close enough to the decorative figures on the candlesticks to pass plausibly as his work, the attempt to attribute to him a tomb in Brescia decorated with bronze reliefs carries little more conviction than the grouping under his name of several bronzes in recherché movement, which were regarded on the flimsiest of evidence as typically Venetian. The problematic personality of Maffeo Olivieri raises the possibility that there may have been provincial schools making small bronzes as well as tomb reliefs in cities such as Brescia; but it should be remembered that the most important centres of small bronze manufacture were in cities in which foundries already existed for the production of larger and more spectacular works. This principle applies not only to Florence, Padua and Venice, but also to such relatively minor centres such as Siena and Recanati.

1527, the year of the sack of Rome by the Imperial troops, is one of the important watersheds in the history of art. It is possible to exaggerate the psychological effect of this disaster, but it is an unquestionable fact that it scattered throughout Italy and beyond, many artists whose style had been formed in close proximity to Michelangelo, and who carried his form of early Mannerism into regions hitherto untouched by this development. Among the artists who fled from the eternal city was the Florentine sculptor Jacopo Tatti, called Sansovino, who settled in Venice. By 1529 he was sufficiently established to be put in charge of the fabric of St Mark's, and his work on the construction of the *Logetta* beneath the bell-tower in the square, the bronze reliefs with the story of St Mark in the tribune of the church, and the bronze doors into the sacristy were undertakings of sufficient magnitude to demand the help of numerous assistants, and thus to ensure that his style would take root and spread in the Veneto.

This style can be judged from the four statuettes of seated evangelists made between 1550 and 1552 for the balustrade of the high altar [figure 42]. Their easy poses and large hands convey a powerful impression of physical force in repose, a legacy of Donatello to the Florentine tradition, but transmitted to Sansovino via Michelangelo's *Moses*, as is proved by the gesture of St John's hand in his beard. A more

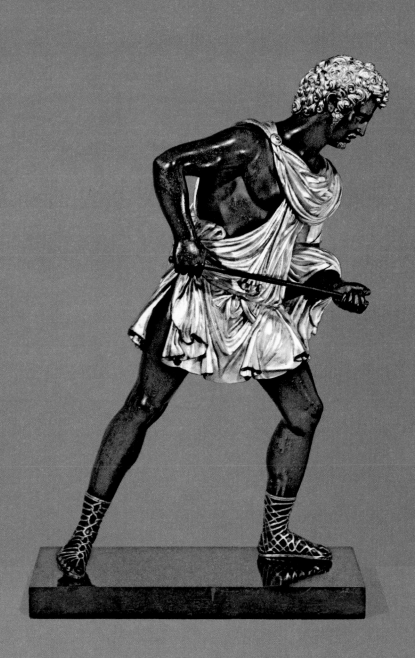

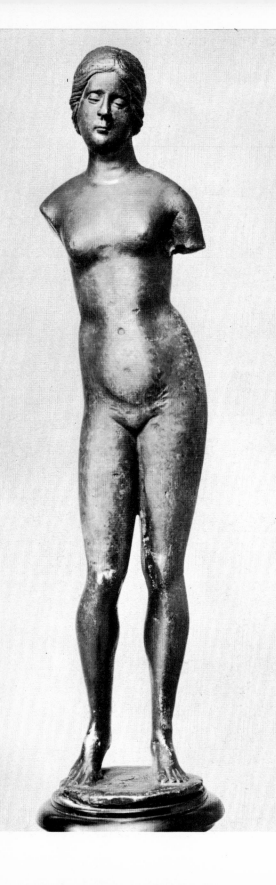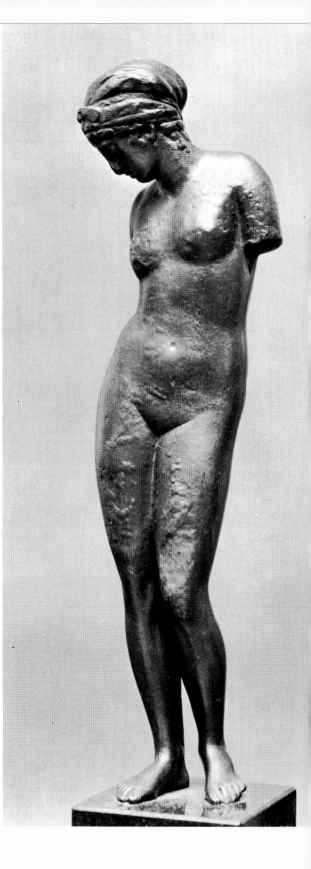

39 (*far left*) A nude woman, usually called Eve, cast without her arms in imitation of a broken antique statuette: perhaps by Tullio Lombardo

40 (*left*) The Maiden of Beroa, by a follower of Polycleitus, late fifth to early fourth-century BC

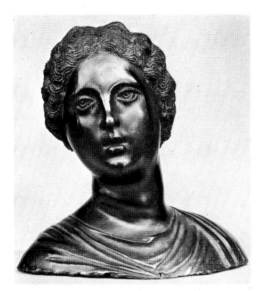

41 Antonio Lombardo's bust of a maiden, which is not directly copied from the antique, but is full of a romantic classicising spirit

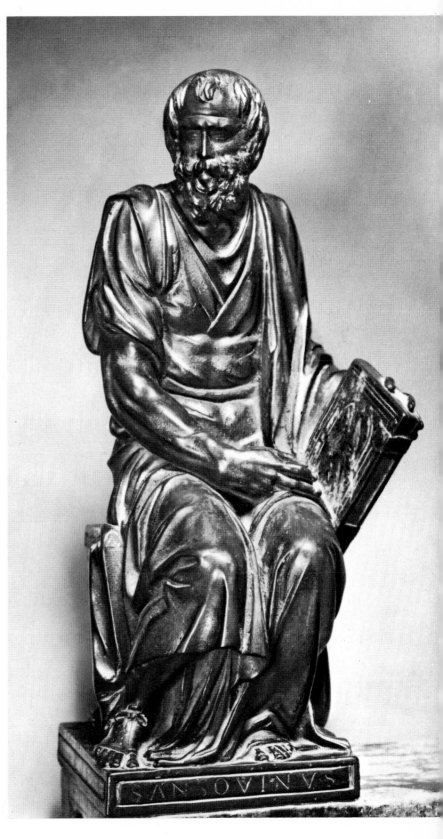

42 (*right*) A bronze of St Matthew, one of the four evangelists made by Jacopo Sansovino for the balustrade of the choir in San Marco in Venice

43 (opposite) A salt-cellar in the form of a kneeling youth bearing a shell, by Girolamo Campagna

self-conscious elegance appears in the exaggerated *contraposto* of Sansovino's *Jupiter* [figure 46], in which the contrasting swing of the hips and shoulders gives some movement in depth to what is essentially a frontally composed figure.

Sansovino's favourite assistant, to whom he bequeathed his models, was Danese Cattaneo, also a Tuscan by birth. Cattaneo was a cultivated poet, and his literary leanings may explain the unusual iconography of figure 48, which appears to be a conflation of *Venus* rising in a shell from the sea with *Fortune* sailing on a turning ball. While this may be an appropriate symbol for a maritime trading city, it could also be a sketch for a figure of *Venus* symbolising copper, which, with the *Moon* for silver and *Apollo* for gold, was to decorate the fountain in the Zecca, with a symbolism drawn from alchemy.

Tiziano Minio, son of a Paduan bronze-founder, was another of Sansovino's assistants, and the sturdy figure of *Neptune* from Sansovino's workshop [figure 27] with its less certain anatomy and stringy beard has usually been regarded as his work. The 'Quos Ego' – Neptune commanding the waves, so called from the beginning of the passage in Virgil's *Aeneid* – was a favourite excuse for displaying a male nude in an imperious turning posture, and the same subject was illustrated in a more masterly fashion by Alessandro Vittoria [figure 26]. Eight years younger than Tiziano Minio, he had broken from Sansovino's teaching to develop his own work in the full Mannerist style. Where the maker of figure 27 dissipates the force of his *Neptune* in a centrifugal movement, Vittoria screws his inwards, concentrating the energy until it bursts forth in the sharply turned head with the suddenness of a shouted command.

A similarly introverted movement suggests the huddled cold of *Winter* [figure 47], and instead of breaking excitedly over the details of the muscles, the light here flows along the broad planes of the drapery. Vittoria copied some of Michelangelo's figures, and owned prints and drawings as well as the youthful self-portrait in a convex mirror by Parmigianino; these common influences explain the relationship of his spiralling, elongated figures to the work of his Florentine contemporary, Giovanni Bologna. But Vittoria's art remains essentially Venetian: the muscles serve less to articulate the body than to send the light rippling over the surface in contrasted highlights and shadows like a Tintoretto drawing, or the sweeping edges of his drapery will

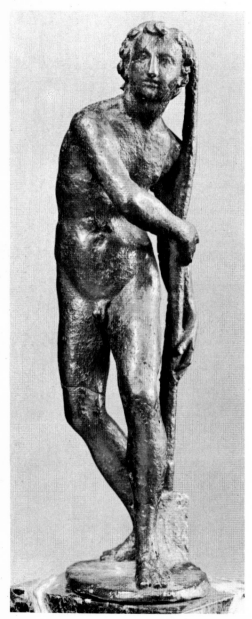

44 Tubalcain, a varient of one of the figures from the candlesticks made by Maffeo Olivieri for the Bishop of Brescia

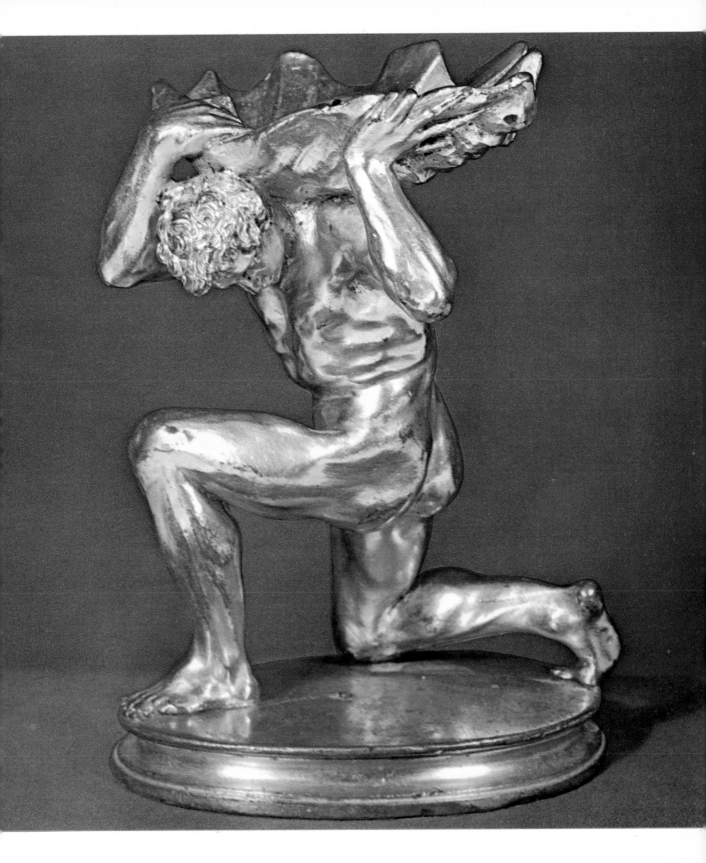

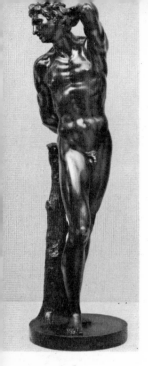 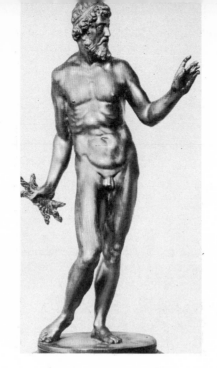 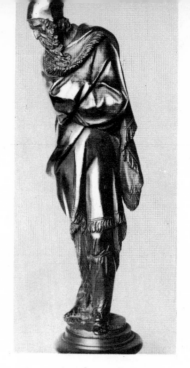 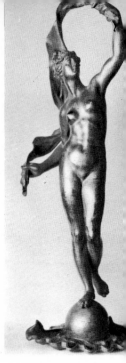

Left to right:

45 St Sebastian, by Alessandro Vittoria

46 Jupiter, by Jacopo Sansovino

47 Winter, by Alessandro Vittoria

48 Fortune, or Venus rising from the sea, by Danese Cattaneo

49 The Negro Venus, possibly by Alessandro Vittoria

throw up a flash of light as long and straight as a brush-stroke by Schiavone.

It is this colouristic quality of his art which still supports his authorship of the *Negro Venus* [figure 49], against the powerfully canvassed claim of Cattaneo. It is not so much her facial features which justify her name, as the modelling of her body, sinking with fluid weight from her long neck to her broad hips and thighs to flow away to her feet, a long, gently curved form over which the light washes evenly as over smooth black skin; perhaps the title of 'Dark Venus' which the Metropolitan Museum now gives to the best version is more than a modern euphemism. This exquisite bronze of a nude admiring herself in a mirror was probably made as an allegory of Vanity.

An historian, writing in 1858, but presumably relying on an earlier source, speaks of Vittoria's interest in the technique of casting. Yet we know that in 1566 he paid a certain Andrea for casting a *St Sebastian* from a wax model he had supplied, and that another *St Sebastian* was cast for him in 1575 by Andrea's son-in-law, Horatio. It must have been one of these which was found in his studio on his death in 1608, and which he instructed in his will should be sold to 'some Prince or other person who would appreciate it'. One of the two may be identified with the bronze in the Metropolitan Museum, signed with his initials [figure 45], while in his portrait by Veronese he holds a slightly different

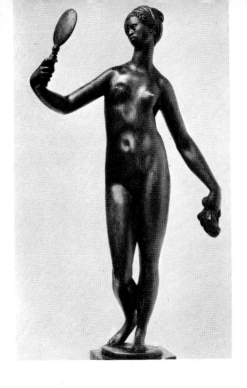

model in plaster or marble; both are variants of the marble *St Sebastian* he carved in 1561–3 for the altar of S Francesco della Vigna in a Michelangelesque pose, which recurs in many of his figures.

If Vittoria did not himself cast such highly valued statuettes, it is even less likely that the many bronze door-knockers, candlesticks, and fire-dogs in his style come from his own hand. Indeed the wide variations in quality and the coupling on pairs of fire-dogs of bronze figures known to have been invented by different artists suggest that these were most often made by artisan founders, adopting the style in vogue at the time or re-casting the master's original models, and continuing their trade in them long after the death of their creator.

Among the more distinguished of such works are the fire-dogs in the Ca' d'Oro, surmounted by *Meleager* and *Atalanta*, which are in the characteristic style of Girolamo Campagna, who also made the model of a kneeling man bearing a shell to serve as a salt-cellar [figure 43]. Another quite unusually fine example of this type of applied art is the door-knocker attributed to Tiziano Aspetti [figure 55]. The graceful elongation of his women never diminished their well-built forms, and their fluttering draperies may have had a special appeal for the eighteenth-century artists of the Venetian Rococo, who often returned to the refined elegance of the sixteenth century, and copies and adaptations of bronzes such as his *Judith* continued to be produced in the workshops of Venice.

The relationship between painters and sculptors in Venice was particularly close, and while Niccolò Roccatagliata is said to have made wax models to help Tintoretto in his painting of violently foreshortened figures, the influence of Tintoretto on Roccatagliata is most evident in bronzes such as the *Bacchus* [figure 53]. Turning with the easy grace of controlled, almost feline power, he could have strayed from a Tintoretto painting. As in so many of that master's works, the modelling of the anatomy is designed primarily to create a contrast of light and shade over the body, while the rough black lacquer breaks the highlights into the semblance of scumbled white paint.

Roccatagliata's speciality was the *putto*, a conventionalised little fellow of indeterminate age, with rounded cheeks, prominent eyelids which catch the light like those in Bassano's paintings, and with his hair piled above the centre of his forehead and on his temples [figure 50]. Like the models

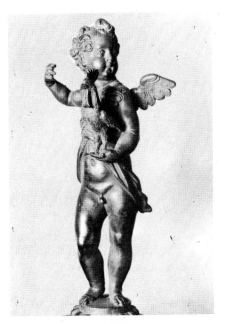

50 Putto with a cock, by Niccolò Roccatagliata

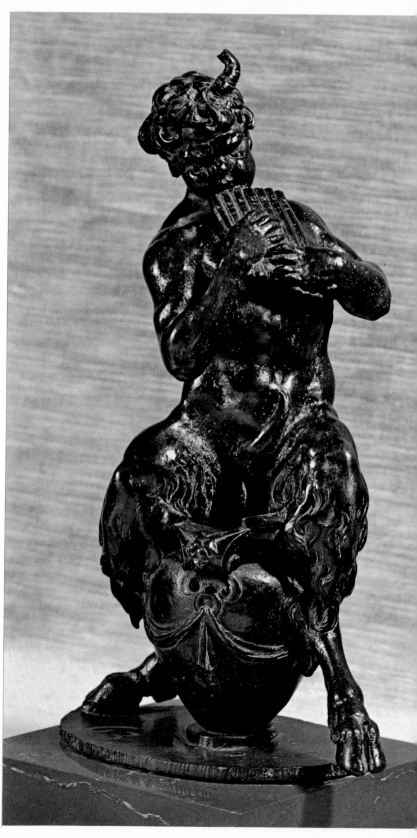

51 (*right*) A faun on a vase made by Niccolò
Tribolo for Cosimo I de' Medici

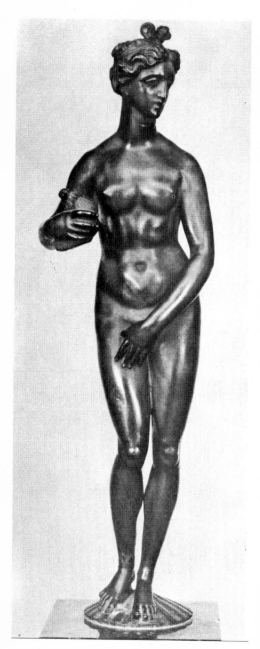

52 Bandinelli's Venus with a dove, her pose
freely adapted from the Medici Venus

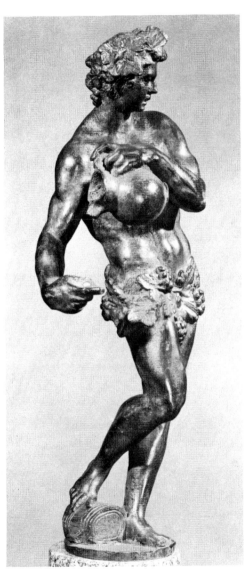

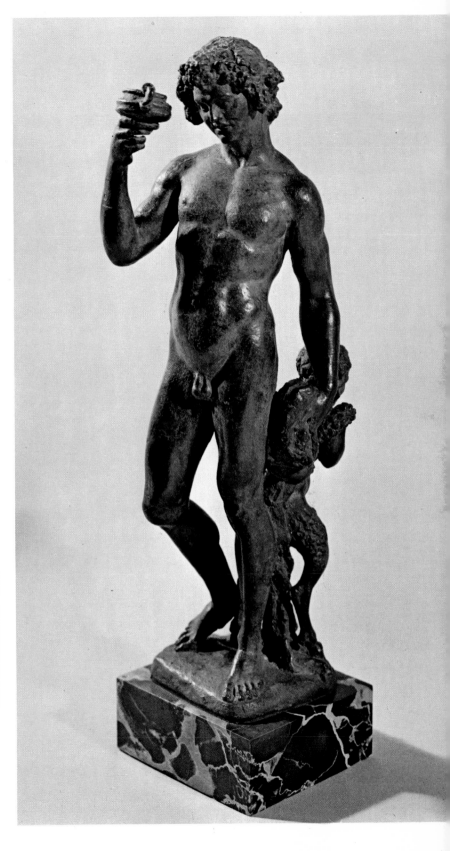

53 (*above*) The black lacquer, typical of Niccolò Roccatagliata's work, gives his Bacchus an intense *chiaroscuro*

54 (*right*) Pietro da Barga made this Bacchus with a satyr, a reduced and slightly altered version of Michelangelo's marble, for Cardinal Ferdinando de'Medici

55 A door-knocker of unusually high quality, modelled by Tiziano Aspetti

of Aspetti, these were frequently repeated over a long period, so that often a Roccatagliata *putto* designates a species rather than the autograph work of a particular sculptor.

While the small bronze had flourished in North Italy, during the early sixteenth century it had almost vanished from Florence. One theory is that Savonarola's preaching had killed it, and certainly an art so closely linked with pagan antiquity and so obviously a luxurious 'vanity' would have withered in the blast of his puritanical zeal. Later, the presence of Michelangelo creating his monumental marble sculptures must have diverted other sculptors from the miniature and frankly decorative arts.

But with the rule of Cosimo I in 1537 there opened a new era in which political stability combined with courtly luxury and enlightened patronage to make Florence once more the centre of the arts, and during the latter half of the century the small bronze flourished as never before in that city. We have in the autobiography of Benvenuto Cellini an invaluable account of the life of an artist at this court; he presents a picture of a duke who took a personal interest in his artists and their work, even if this did not always extend to paying them, and of painters and sculptors intriguing for his favour, and competing with ever new displays of virtuosity and proofs of their artistry.

The bitter enmity of Cellini has done much to discredit his older rival, Baccio Bandinelli; their differences extended to their artistic aims, for Cellini, with his preference for grace-

fully sinuous or expressive movement, could not appreciate the precision of statement and clarity of form in Bandinelli's work. Many of Bandinelli's small bronzes are based more or less closely on the antique, such as his *Hercules with the Apples of the Hesperides* [figure 79] which was in the Medici collection before 1553, and which is taken from an antique formerly in the Uffizi [figure 94]. But the bronze is very much his own creation, in which the light-reflecting qualities of the material are used to bring out the sinewy ridges and muscular planes of his arms and thighs, and the broad bull-like head is given that inexpressive mask so typical of Florentine Mannerism, whether it be in a portrait by Bronzino or the vacuous stare of Bandinelli's own marble *Adam*, unveiled in 1549 and derived from the same antique prototype. Equally free from any emotion is his *Venus with a Dove* [figure 52], a variant of the antique *Medici Venus*, displaying even more clearly Bandinelli's precise outlines and restricted interior modelling, which is just sufficient to define the body's articulation.

Bandinelli is less widely known today for these delicately modelled statuettes than for the huge marble *Hercules and Cacus* in Florence, in which the stolid frontality and inexpressive anatomy appear merely grotesque. Its failure seems even more regrettable when we remember that it is carved from the block in which Michelangelo had planned to create his *Samson Slaying the Philistine*. The group with two Philistines may be slightly later than the project of 1528, but it is this group which has been popularised in numerous small bronze reproductions [figure 56]. These have been attributed to Daniele da Volterra, who must have known the group as he included it in his painting of the *Massacre of the Innocents*, and also to Pierino da Vinci who, according to Vasari, had access to Michelangelo's sketches when he was preparing his own group of the same subject. From a comparison of the many versions, of which that in the Frick Collection is one of the best, it is evident that they are the work of several different hands, nor have we sufficient examples of the bronzes of either Daniele or Pierino to make a meaningful attribution.

One bronze can now be securely identified as the work of Pierino's master, Niccolò Tribolo. J. Holderbaum has published the note of 1549 in which the founder, Zanobi Portigiani, recorded that he had cast a small bronze satyr for Tribolo. This is the little satyr who wriggles delightfully upon an ovoid vase, puffing vigorously at his pipes [figure 51]. His

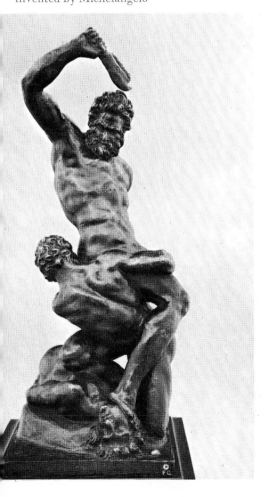

56 Samson slaying the Philistines, one of the best of many bronze versions of the group invented by Michelangelo

43

lively twisting movement makes for a complexity of varying views, none wholly self-sufficient, so that he demands to be swivelled round and admired from every side. The surface, chiselled in small facets and left rough and appealing to the touch, seems to have come from a different world to that of Bandinelli's smooth Olympian gods, yet both artists worked for Cosimo I, and the goat-mask on the vase was one of Cosimo's *imprese*.

Cellini tells how Cosimo and he worked together to chip the dirt from some newly discovered antiques, and from his taste in contemporary bronzes we may guess that Cosimo restored them to a smooth and polished surface. But his younger son Ferdinando evidently did not share this taste, as we may judge from the small bronzes which, when a Cardinal in Rome, he commissioned from Pietro da Barga, and some of which he had incorporated into the decoration of his study. Most of these are covered with an uneven green varnish applied over a none too precisely chiselled surface, and in some cases they are heightened with gilt details. They are all reductions of well-known masterpieces, mostly antiques, though some, such as the *Bacchus* [figure 54] are after Michelangelo.

We learn more of the fashion for this green varnish, designed to imitate the patina on antique bronzes dug from the earth, from a letter which the Milanese sculptor Leone Leoni sent to Cardinal Granvella, Bishop of Arras, in 1555. He was sending him four bronze portraits which he had covered with a green varnish which toned down the polish and seemed to him the most suitable. 'The colour of candlesticks', he writes, meaning presumably the light brassy tone, 'did not look well, and the black is melancholy and would have made the figures look like Indian moors; therefore I chose the light green which is cheerful and competes with the antique figures. If it does not please Your Excellency, as on the contrary it pleases many people, it will be very easy to return these bronzes to their original state, and then it will be known that they are not only rubbed with pumice, but even polished'. Apparently Cardinal Granvella did not like it, for three of the busts, now in the Vienna collection, are a natural brown colour, and fully bear out Leoni's insistence that they were perfectly finished, and that the patina was not intended to hide his inadequate workmanship. Still, whether in a copy like the Marcus Aurelius [figure 1], or in the green patina, artists of Renaissance Italy strove to compete with their classical predecessors.

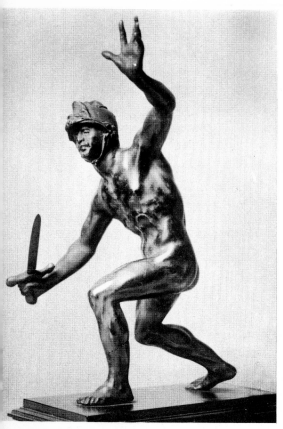

57 Leone Leoni's crouching warrior, rather similar in type to those below Cardinal Granvella's bust of Charles V

Renaissance Germany

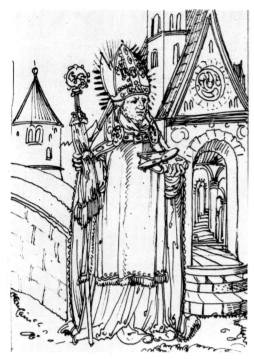

58 Georg Kölderer's drawing of St Landricus from the Codex Vinob. 2857 in the Austrian National Library, Vienna

THE ONLY OTHER COUNTRY to produce bronzes of any importance during the sixteenth century was Germany, but even in Germany bronze was never as popular an artistic medium as in Italy, and it seldom reached a comparable standard of excellence. While the bronze doors and fonts of German cathedrals such as that of Hildesheim rank among the greatest artistic achievements of the early Middle Ages, wood and stone were the traditional materials of German sculptors, and bronze-founding was a separate craft. Often the founder commissioned his model, usually in wood, from an independent sculptor. This situation, besides bedevilling all attempts to attribute German bronzes to sculptors, as against the founder to whom the commission would most likely have been given, and who may even have signed the bronze, helped to perpetuate a conservative outlook, which would be slow to seize the advantages which the small bronze offered for artistic experimentation.

But a more fundamental reason for the comparative poverty of artistic German bronzes lay in the absence of that strong and living antique tradition which had provided a constant stimulus and challenge to the Italians. It was not so much that the artists lacked models, for imitations of antique types can be found throughout the history of the German bronze, but that they lacked the support of a sophisticated public, which in Italy appreciated these specimens of artistic skill and followed with sympathetic and informed concern each attempt to rival or surpass the ancients. Humanists were not rare in Germany, but they tended to regard the relics of antiquity rather as historical documents than as aesthetic exempla, and few of them seem to have commissioned their own artists to make copies or imitations. The exception to this is the medal, and it was to this art, also a revival of the antique, that humanistically inclined Germans gave their patronage, in preference to the small bronze.

So the independent collector's bronze is a rarity. Most small bronzes are either by-products of the goldsmith's art, such as the stag with a break in its neck [figure 68], which was cast from a model for one of those cups in the form of an animal

59 St Landricus, modelled by Leonard Magt from a design by Georg Kölderer and cast by Stefan Goedl for the funerary chapel of the Emperor Maximilian at Innsbruck

with a removable head; or they formed part of a larger complex, such as one of the fountains which adorned the city square, the palace court-yard and garden, or even the dining table. The centre of the industry was in what is now Bavaria, and one of the leading workshops was that of the Vischer family in Nuremberg. Their greatest undertaking was the bronze canopy round the reliquary of St Sebald [figure 61], commissioned from Peter Vischer the Elder in 1488, and finished in 1519. The most significant date, however, is 1514, when the work was transferred from the charge of Peter the Elder, to his first son Hermann, at least nominally, for in fact it appears to have been another son, Peter the Younger, who took the major share in the work, and whose journeyings in Italy inspired the break from the original Gothic design to one in the new Renaissance style.

Although it was the younger generation which was most strongly orientated towards Italy and the antique, Peter Vischer the Elder cannot have been untouched by this source of new motifs if indeed it was he who made the *Hercules and Antaeus* in Munich [figure 67], the same mythological subject which had inspired Pollaiuolo some thirty years earlier [figure 14]. The German pair are comparatively weak in expressive tension, a defect due less to their commonplace poses than to the imprecise finish, the clumsy hands and heads and slackness of surface. That the group was once fully gilt suggests a taste which valued the bright glitter and precious appearance of gold above the more sophisticated qualities of invention and modelling.

Quite a different approach is evident in the work of Peter Vischer the Younger. The splendid dignity of his standing Apostles around the Sebaldus Shrine was to inspire so many nineteenth-century imitations that it is hard to see them afresh, but the remarkable impressionistic treatment of the Prophets on the pinnacles remains a technical achievement of extraordinary brilliance. Obviously Italian in derivation are the four allegorical female figures on the base, and the seated male nudes at the corners are thought to represent Samson, Nimrod, Hercules and Theseus. The profusion of *putti* rollicking over the architectural framework and the monsters of pagan antiquity remind us of Riccio's contemporary Santo Candlestick [figure 28], though the direct influence of the Sebaldus Shrine on the small bronze industry was considerably less.

The only parts of the Shrine to be reproduced in independent bronzes (apart from the portrait of Peter Vischer

60 The harder modelling on this pilgrim by Hermann Vischer shows that it was cast from a wooden model

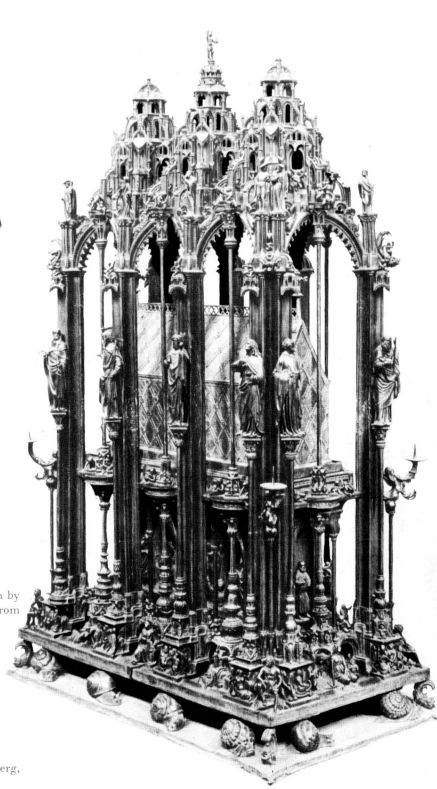

61 The shrine of St Sebaldus, Nuremberg, made by the Vischer family, 1488–1519

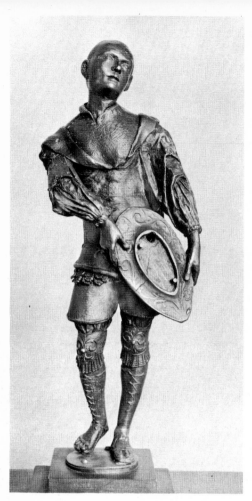

the Elder, of which several copies exist, mostly made much later) were the *putti*, playing alone or clasping their playful dogs. Most casts of these are coarse in execution, which is hard to reconcile with works so small and apparently domesticated. Clearly related to these in feeling, but derived from a dry-point by the Housebook Master, is a dog scratching itself with such evident ecstasy, a subject turned out in considerable quantity by the Vischer workshop in Nuremberg, though again some versions may be of more recent origin than those.

62 A page, formerly displaying a coat-of-arms, made in Augsburg about 1530–40

63 (*far right*) An inkwell with the figure probably symbolizing Vanity by Peter Vischer the Younger, whose emblem and motto it bears

64 (*right*) Another inkwell by Peter Vischer the Younger, dated 1525, with the same motto: *Vitam non mortem recogita*

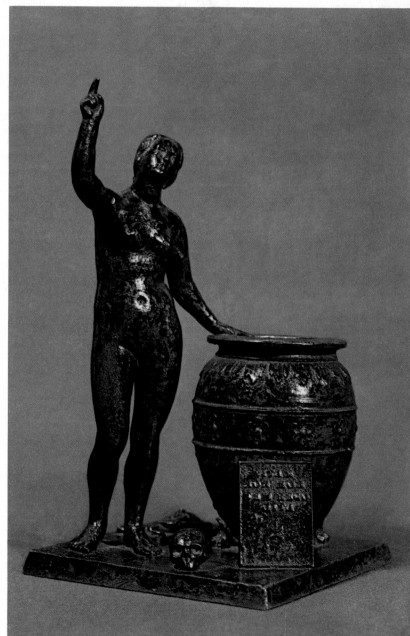

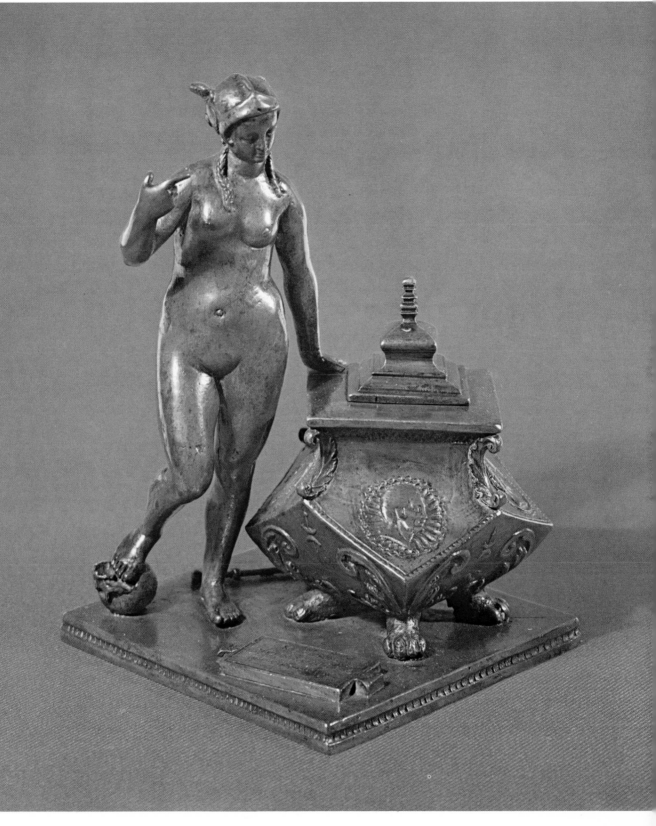

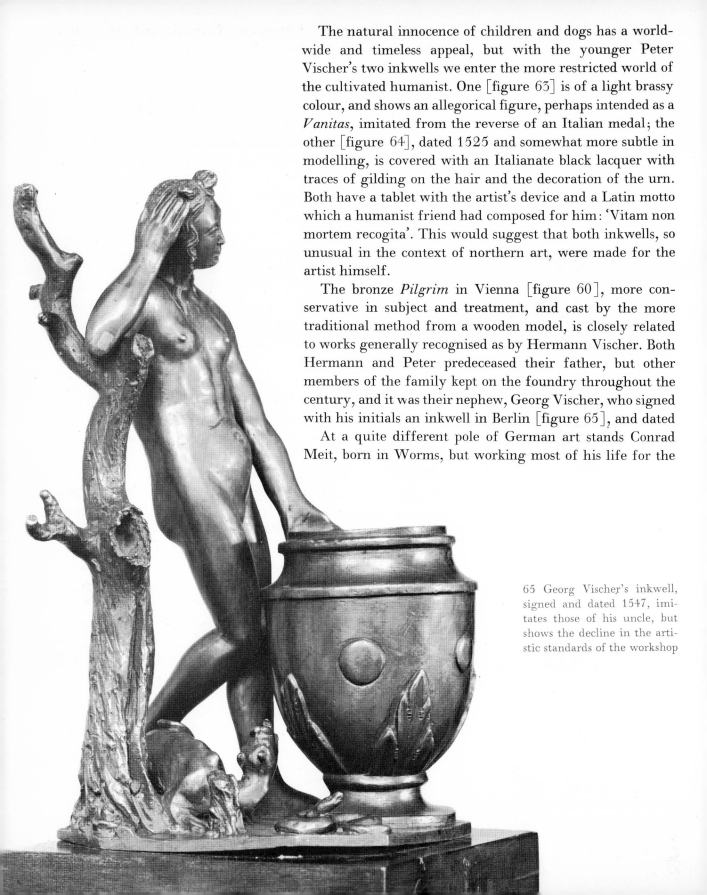

The natural innocence of children and dogs has a world-wide and timeless appeal, but with the younger Peter Vischer's two inkwells we enter the more restricted world of the cultivated humanist. One [figure 63] is of a light brassy colour, and shows an allegorical figure, perhaps intended as a *Vanitas*, imitated from the reverse of an Italian medal; the other [figure 64], dated 1525 and somewhat more subtle in modelling, is covered with an Italianate black lacquer with traces of gilding on the hair and the decoration of the urn. Both have a tablet with the artist's device and a Latin motto which a humanist friend had composed for him: 'Vitam non mortem recogita'. This would suggest that both inkwells, so unusual in the context of northern art, were made for the artist himself.

The bronze *Pilgrim* in Vienna [figure 60], more conservative in subject and treatment, and cast by the more traditional method from a wooden model, is closely related to works generally recognised as by Hermann Vischer. Both Hermann and Peter predeceased their father, but other members of the family kept on the foundry throughout the century, and it was their nephew, Georg Vischer, who signed with his initials an inkwell in Berlin [figure 65], and dated

At a quite different pole of German art stands Conrad Meit, born in Worms, but working most of his life for the

65 Georg Vischer's inkwell, signed and dated 1547, imitates those of his uncle, but shows the decline in the artistic standards of the workshop

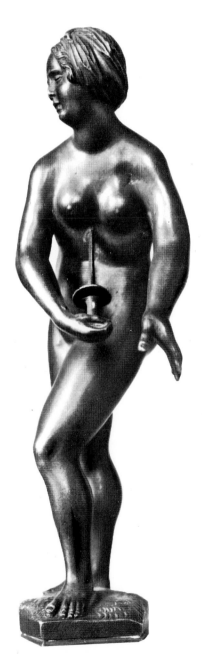

cosmopolitan court of Margaret of Austria, and one of the leading sculptors in her burial chapel at Brou. The female nudes which predominate in his small sculpture show something of the softer French approach to art and to the human body, combined with that stylish suggestion of sensuality which he learned from his time in the studio of Lucas Cranach. Even Lucretia, drastically proving her devotion to chastity, cannot forget to take up a pose of seductive elegance [figure 66]. This bronze in Brunswick is a variant of a boxwood statuette of the same subject in New York, and has been regarded as the product of Meit's workshop, for, even allowing for its damaged surface, it lacks the taut and detailed modelling of his original.

Meit's *Lucretia* derives from an engraving of about 1514 by Lucas van Leyden, itself inspired by a print of Marcantonio Raimondi. It was also an Italian engraving which guided Peter Flötner in his model of 1531 for the *Apollo Fountain* in Nuremberg, this time by Jacopo de' Barbari, the same who had inspired another Nuremberg artist, Albrecht Dürer, to investigate the secrets of human proportion. From this circle must have come the anonymous master of the *Walking Youth* in Vienna and the almost identical figure in Munich [figure 81], studies of the naked human body with a classical quality and an ease of movement which have led some to regard them as Italian.

The drapery of the Viennese *Youth*, lacking in the Munich version, was cast from real cloth, and this technique of casting from nature was very popular in the sixteenth century. Paduan bronze founders made casts of crabs [figure 3] and small reptiles, while lizards and insects and mosses abound in the goldsmith's work of the German Wenzel Jamnitzer; snakes and fishes were reproduced on the ceramics of Bernard Palissy in France, and similar cast animals appear on works like the Nuremberg *Apollo Fountain*. it 1547. The inspiration obviously comes from Peter's model in Oxford, but the proportions and modelling betray all too clearly the decline in artistic sensitivity.

While the Vischers continued the Nuremberg tradition of bronze-founding, a new foundry was set up at Mühlau, near Innsbruck, for the express purpose of preparing the sculptural decoration of the chapel which the Emperor Maximilian I had devised for his tomb. This immense and uncompleted project was to contain images of the ancestors of the house of Habsburg, real and legendary, and to include one hundred statuettes of their patron saints. The programme for these statuettes was

66 Lucretia, cast by the workshop of Conrad Meit, in imitation of his boxwood models

51

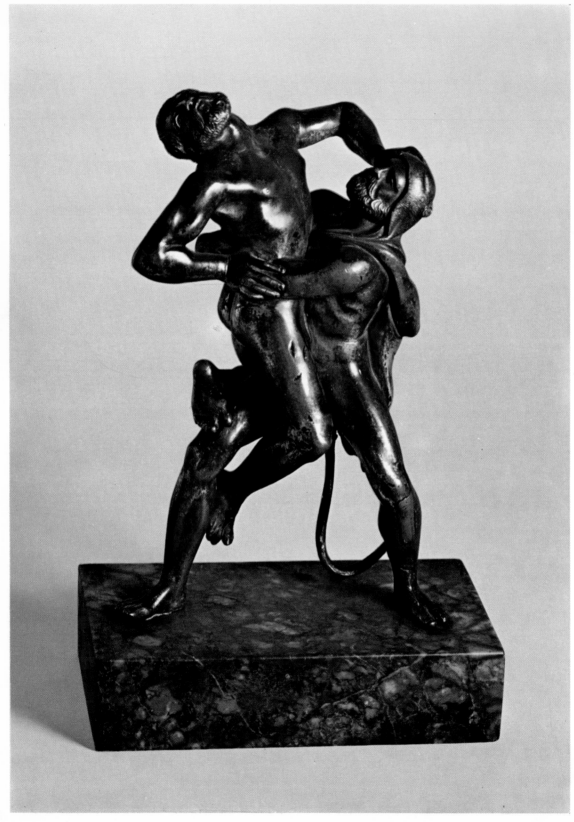

67 (*left*) Although Peter Vischer the Elder's Hercules and Antaeus is derived from a model such as that of Pollaiuolo, the workmanship is cruder, and would have been only partially disguised by its former gilding

68 The break in the neck shows that this stag, made at Nuremberg about 1530, was cast from a goldsmith's model for a cup, in which the head could be taken off to serve as a drinking vessel

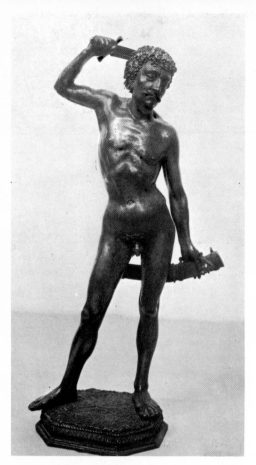

69 In 1525 the Archduke Ferdinand of Tyrol ordered Stefan Godl to cast this naked warrior as a proof of his skill, on which the Archduke had laid a wager

70 A prancing unicorn by Hans Reisinger

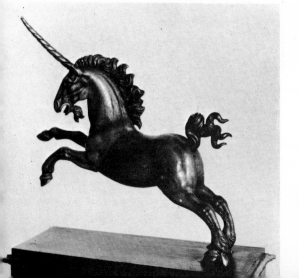

elaborated by the Friburg professor and Imperial counsellor, Jacob Mennel, and the court painter and architect, Georg Kölderer, made the drawings [figure 58]. From 1514 on Leonhard Magt was employed to make the models, and in 1514/15 Stefan Godl, a founder called in from Nuremberg, began to cast them. The twenty-three figures which they completed [figure 59] stand forcefully on their large feet, with a directness of characterisation and a strong, even brutal modelling which stresses their sculptural volume. Yet Magt and Godl have retained something of the style of Kölderer, his love of curling decorative lines so typical of the so-called Danube school, and in the damask decoration, applied to the model in wax stamped from a mould, they created a surface of corruscating light of unusual depth and richness.

After the death of Maximilian the work continued under the direction of the Archduke Ferdinand of Tirol, who was evidently so impressed with Godl's skill that he made a wager that he was the best founder in the country. On December 9, 1525, he ordered Godl 'to cast immediately a whole naked man, standing, in a clever pose, proportioned in the nicest and most diligent manner, with the elbow raised high', and he should make it 'so that the casting would come out well and no one would need to help with filing it or in any other way' (as goldsmiths had been employed on finishing some of the Innsbruck tomb sculpture) and, finally, he was admonished to do it 'with all diligence, art, and appropriateness' and 'not to let his Highness lose'. The bronze was delivered in February of the following year, and while we do not know the outcome of the bet, the bronze is still in existence [figure 69]: a naked warrior of uncompromising naturalness, and a fine example of the founder's art. As Godl is not otherwise known as a sculptor, we can assume that Magt again supplied the model, for the warrior is a close relative to many of the Innsbruck saints.

Another bronze which is generally assumed to have some relationship with the Innsbruck tomb is the *Madonna and Child* by Hans Leinberger [figure 71]. In 1514 he was commissioned to make the large statue of Albert the Great for the series of Habsburg ancestors and the metal was sent to him in Landshut; but in 1518 the metal was returned and the statue cast from Leinberger's model by Stefan Godl. The *Madonna and Child* may represent the work of the intervening years, when this superb wood-carver was experimenting in an unfamiliar medium. Certainly it would

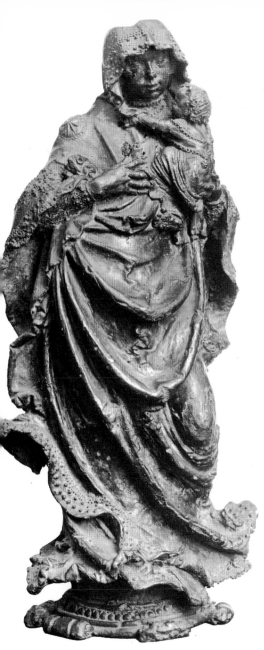

71 Madonna and Child, one of the very rare bronzes by Hans Leinberger

not have shaken the laurels on Godl's brow: the cast has emerged with a number of holes and missing areas, and the sculptor has evidently not considered it worth finishing. Yet the rough surface of the bronze and the technical faults cannot conceal a sculptural power beyond the comprehension of a Leonhard Magt, a vitality in the sweeping lines of the drapery frothing out like a breaking wave, translating the life and energy of the figures into formal terms of strange and satisfying beauty. With his innate sensitivity to the material and medium in which he was working, Leinberger has grasped the full range of expression possible in the contrast of smooth and ruffled surfaces, of closed and openly floating forms, so that today, in an age less enamoured of the highly finished craftsmanship of the artisan founder, even the imperfections of the cast only strengthen the immediacy of communication.

The same method was used for the drapery of three bronze figures, whose graceful Italianate poses and decorated costumes link them with work being done in Augsburg about 1530 under the auspices of the Fuggers, the wealthy banking

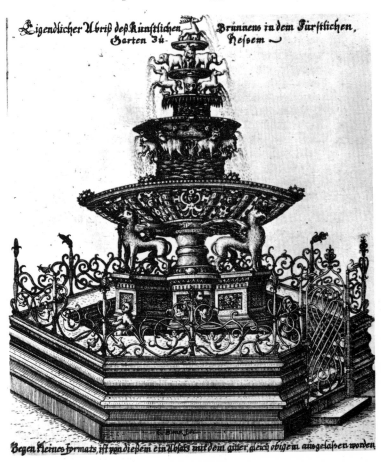

72 A fountain in the Duke of Brunswick's garden at Hessen, made by Augsburg craftsmen

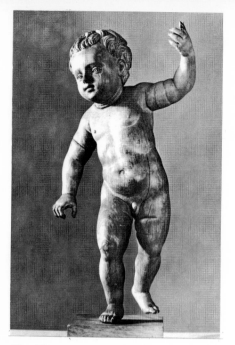

73 The wooden model for the Nuremberg Rathaus putto

family who did so much to introduce Italian Renaissance forms into Germany. The coat of arms which the *Page* [figure 62] must have carried is now missing, and we can no longer know for whom they were made, nor what their original purpose could have been. Almost certainly he and his companions, *King David* and a woman with one hand on a man's head and the other holding a snake to her breast, were once part of a larger series, and they may perhaps have decorated some elaborate fountain.

Such fountains with bronze or brass figures abounded in Germany, and seem to have been a speciality of the founders of Augsburg. The table fountain now in the Victoria and Albert Museum [figure 76] illustrates one type, a fairly mechanical piece of work, put together from some rather crudely modelled naked women, the stags (their coats marked by the short engraved lines typical of the Augsburg craftsmen) and the crowning figure of Actaeon indicating that they represent Diana and her nymphs at the bath. Of a simi-

75 A genre figure of a peasant made in Nuremberg about 1570–80

74 Putto made about 1550 for the Great Court of the Rathaus in Nuremberg

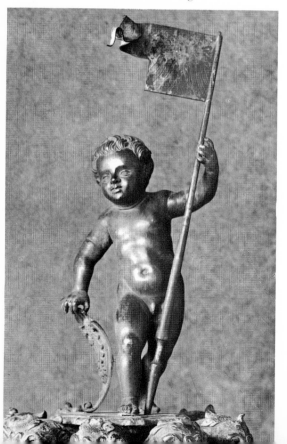

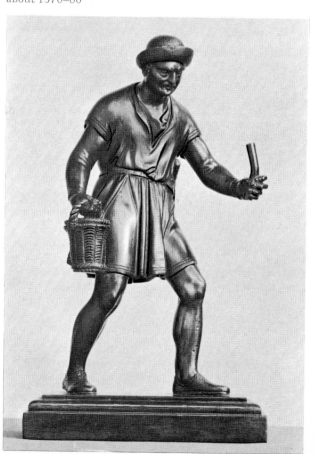

lar semi-industrial quality are various wall-taps in the form of a half-figure of a woman holding two jugs.

To see how complex such work could be we have only to look at the engraving of a fountain formerly in the Duke of Brunswick's garden at Hessen [figure 72]. This was sold to the Duke some time between 1568 and 1589 by merchants from Augsburg and Regensburg, for 8,000 florins. There were crabs, shells and snakes cast from nature, as well as four griffins, bulls, dragons, pelicans, elephants, unicorns, a mountain-goat hunt, and a leaping stag. The spirited brass *Unicorn* in Dresden [figure 70], described in an inventory of 1595 as bought from one Hans Rössinger, may well have come from a construction of this sort. It has been suggested that it had some connection with a pair of imitation rocks in the palace at Dresden; they were surmounted one by Orpheus and the other by a unicorn, and covered with other animals, all of wood; each also carried twenty silver cups, and concealed in each interior was a horseman, who could be set in motion to ride forward and present a goblet. It may be that the animals had once been made of the more costly brass, and that of these originals only two, the unicorn and a stag, still survive, or that Rössinger's brass animals served as models for the later wooden ones.

'Hans Rössinger' is probably a mis-spelling of Hans Reisinger, the best known member of a family of founders in Augsburg. A greater renown was enjoyed by the Labenwolf family in Nuremberg, and it was Pancratz Labenwolf who signed with his initials the famous *Putto* on the Nuremberg Rathaus fountain of 1556 [figure 74]. No one knows, however, who made the wooden model [figure 73] from which it was cast, and which still survives. We read elsewhere of such a wooden model being kept and painted to be admired as an independent statue, but only one other is known today, that of the *Little Goose-man*, made for another Nuremberg fountain which was very probably cast in the same Labenwolf foundry.

The vogue for such genre figures, so different from the classically inspired bronzes of earlier times, seems to have come into German art in the second half of the century. We meet not only exotic soldiers such as those shooting water from their guns which Georg Labenwolf cast in 1582 for a fountain for Frederik II of Denmark, but independent small bronzes of hunters and peasants [figure 75] made, we must imagine, for the delight of some patron wealthy enough to enjoy these artistic representations of the lower classes.

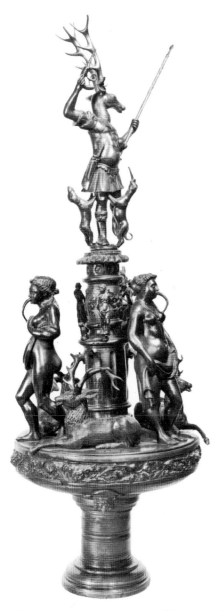

76 This table-fountain with Diana and Actaeon is typical of the fountains in which Augsburg craftsmen specialised in the mid-sixteenth century

57

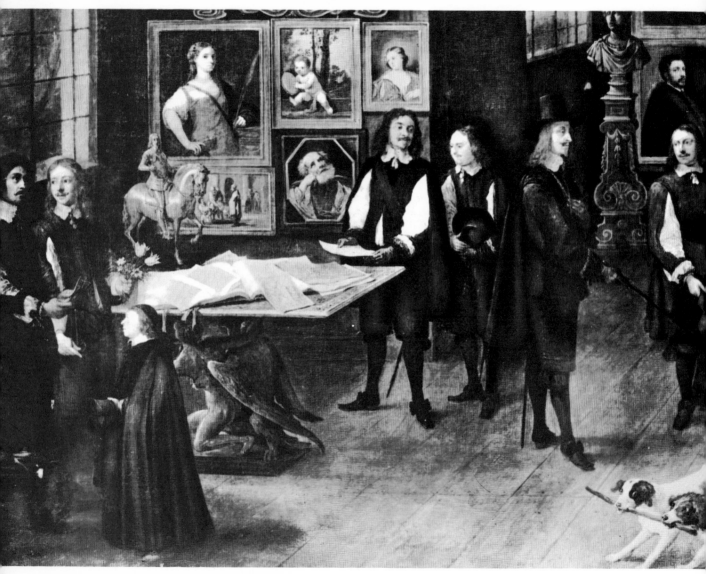

77 A detail of a painting by David Teniers the Younger, showing the Archduke Leopold Wilhelm inspecting his gallery, with a bronze statuette of the Archduke by Suisni on the left

An International Court Art

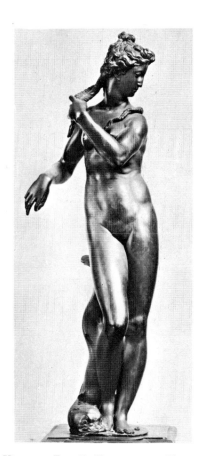

78 Vincenzo Danti's Venus personifies water

THE LATTER HALF OF the sixteenth century and the early years of the seventeenth witnessed one of the most fascinating chapters in the history of the small bronze. A style initiated by one man came to dominate sculpture throughout Western Europe, and established a fashion which was avidly seized upon by every court from Spain to Scandinavia. Of course the bronze statuette was not the only medium of communication by which this art was disseminated. But it can be plausibly argued that it was one of the most potent, and that without these sturdy, easily transportable, and relatively cheap means of reproduction, the style would have spread less widely, and that the transmission of the fashion from the courts which fostered it to the ordinary collector would have been a much slower process.

It is here that technical skill becomes of the first importance, for it was possible for a craftsman at this period to produce a good quality small-scale bronze with a fair certainty of success, and an artist who employed such craftsmen could turn out small reproductions of his work on a quasi-industrial scale, which would in no way compromise the highest standards which he might set himself.

The artist who took such full advantage of the opportunities thus offered to him was Giovanni Bologna, born in Douai (near Boulogne —hence his name, often contracted to Giambologna) in 1524. After some years of study in Rome he returned northwards via Florence, where he was taken up by a group of cultivated connoisseurs, and introduced to the Medici court. This was the period of Grand Ducal rule, when the taste which we have already met with Bandinelli was to culminate in the study of Francesco I [figure 92], a room which preserves the atmosphere of its creator with an almost suffocating intensity. Once the doors are shut they are indistinguishable from the painted doors of the cupboards, and we are enclosed in a little room into which no daylight can enter, and in which, so far from art imitating life, life is cut off from vulgar reality and strives for the illusion of art. The studio of his brother, the Cardinal Ferdinando, no longer in existence, was decorated by Zucchi to include small

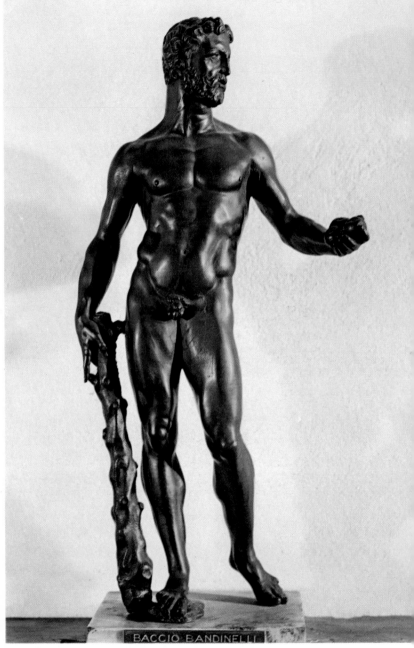

79 Hercules with the apples of the Hesperides, by Baccio Bandinelli

80 Vincenzo de' Rossi's Vulcan working at his forge, symbolises fire

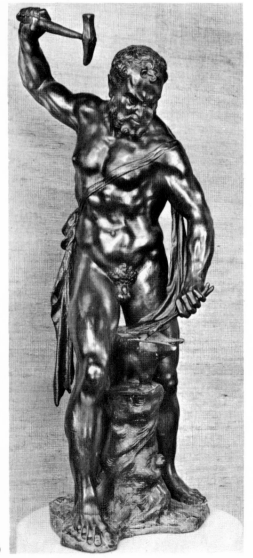

bronzes by Pietro da Barga; that of Francesco incorporated into the grey marble niches of its decorative scheme original bronzes by the leading artists of the day, symbolising the four elements, which provide the theme of the room, a programme whose full meaning, like those of the contemporary emblems, should be open only to the initiated.

Harmonious as is the general effect, the different artists employed here exhibit very different personalities, and not least the eight sculptors. The *Juno* of Giovanni Bandini

81 (*right*) A walking youth, made in Nuremberg about 1530–40, under the influence of the Italian Renaissance

82 Juno, by Giovanni Bandini; as the commander of winds she appears in the Studiolo as the symbol of air

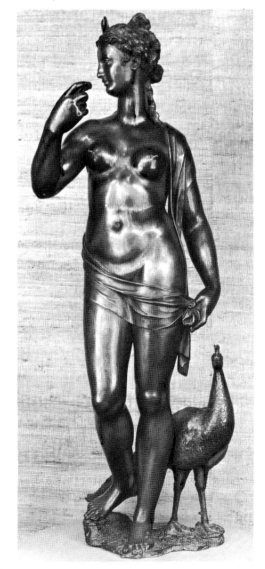

83 Apollo the Sun God also symbolises fire, but Giovanni Bologna's statuette is in complete contrast to Rossi's Vulcan (figure 80) in the Studiolo

[figure 82], paid for between 1572 and 1573, carries on the ideals of his teacher Bandinelli, using an upright pose emphasised by the meagre drapery, a clear demarcation of the parts of the body, and a simple frontality with the head turned into direct profile, to create the imperious presence of the queen of the gods and commander of the winds. Vincenzo Danti's *Venus* [figure 78] shows quite a different approach to the female body: as a niche figure she too is frontal in construction with her head in profile, but, avoiding all straight lines, she sways in a gentle curve, her bent knee relaxing the stiff frontality, her hair repeating the sinuous line, and her right hand hanging limply bent in elegant relationship to her body, so that she seems to float silently through the water she personifies. Very different again is the noisy *Vulcan* [figure 80] for which Vincenzo de' Rossi was paid in 1572; Rossi's tendency to fussy detail is evident here in the sinewy arms and almost caricatural features of this bronze, which adapts the pose of his marble *Hercules*, made in 1568 for the same palace. Nothing could be further from this uncouth *Vulcan* than his companion personification of fire, the *Apollo* [figure 83] which Giovanni Bologna made from 1573 to 1575. He is the epitome of sensuous grace and elegance, and his soft forms look almost feminine till we set them against the even gentler modelling of the bronze *Astronomy* [figure 84] a mirror-image of his pose. Apollo's hair is chiselled with extreme delicacy [figure 6], deep and freely curling and full of life, and the whole surface has that clean tautness which is the hall-mark of Giambologna's autograph bronzes.

Giambologna's style was compounded of the elongation made fashionable by Parmigianino, the cold impassivity which had become characteristic of Florentine late mannerism, and a search for powerful movement influenced by his much-admired Michelangelo. These elements he blended into a series of works whose refined complexity of movement and calculated harmony of balance are poised where perfection borders on affectation.

The fascination which the turning form exerted on artists at this time was connected with contemporary aesthetic demands for sculpture which should be equally harmonious and interesting from every view-point. From all that has been said it should be obvious that the small bronze was ideally suited for the exploration of such forms. It was as an exercise in this problem, combined with the equally intriguing task of fitting two figures into a formal unity, that

Giambologna made the group in figure 9. When on June 13, 1579, he wrote to Ottavio Farnese, Duke of Parma, to tell him that the group was completed, he was quite indifferent to the subject: 'The two aforesaid figures which can represent the Rape of Helen or perhaps of Prosperina [Proserpina] or of a Sabine' were chosen 'to give an occasion for the knowledge and study of art'. Only later, when he repeated the group in marble with the addition of the third figure of an old man made, so it was said, to show his skill at representing all ages, did his friend Borghini decide on the title by which we know it today, *The Rape of the Sabines*, and the artist added an explanatory relief on the base.

In the same letter Giambologna emphasized that he himself had finished the bronze, so avoiding the damage which inexpert chasing and filing could do to the modelling. From this we might assume that usually such work was carried out by assistants, and this assumption is confirmed by the fascinating letters to the Duke of Urbino from his agent in Florence, Simone Fortuna. The Duke was anxious to purchase two marble statuettes from Giovanni Bologna for his study, and Fortuna devotes all his powers of salesmanship to persuading him that bronzes would be much more suitable. He assures him that all the best people are having bronzes, the King of Spain, the Pope, Cardinal Ferdinando, the Duchess and Grand Duke, who wants all his small objects in bronze. He makes the point that on a small scale the sinews and workmanship show up much better in bronze than in marble, and that bronze is far less likely to break in transit. But his most unarguable point is that Giambologna is too busy to undertake any work in marble, 'because in such small

84 In the figure of Astronomy, Giovanni Bologna reversed the pose and softened the forms of his Apollo

85 A painting by Jan Breughel the Younger of Venus and Cupid in an imaginary collector's gallery, with many models by Giovanni Bologna

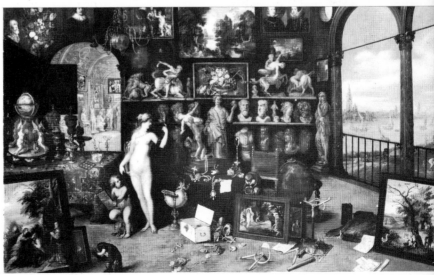

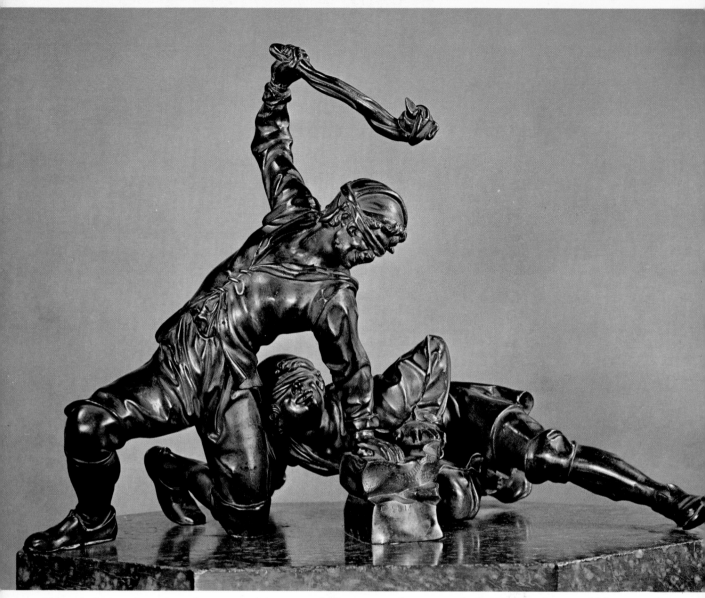

86 Boys playing the game of *saccomazzone* by Orazio Mochi

works he cannot have any help, that is, he would have to do it *all* by himself'. If, however, the Duke would agree to have a bronze, 'in that case he would promise to serve you very well, and to have it finished, he said at first in a year, but for love of me [Fortuna] he could arrange it so as to have it ready in six or at most eight months, because once the models are made in clay or wax, which can be done quite quickly by his hand, they will be given at once to have moulds made in plaster, and then to be finished off by the goldsmiths whom he employs specially for His Highness [the Grand Duke of Tuscany]'.

Such private purchases as these were only one of the ways in which Giambologna's bronzes were spread. The

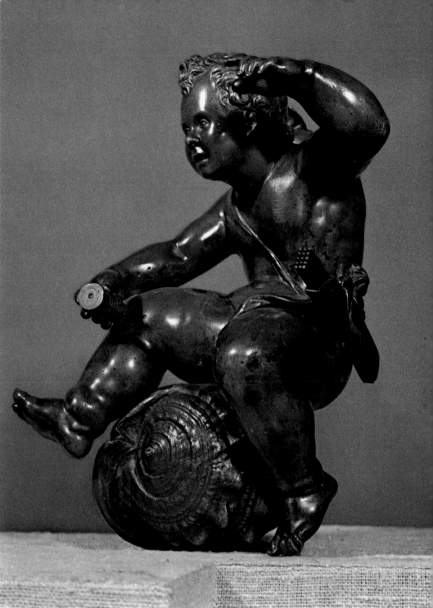

88 Giovanni Bologna's crouching Venus is a reduction of an antique prototype

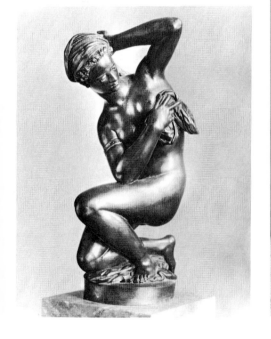

group in marble with the addition of the third figure of an old man made, so it was said, to show his skill at representing all This was the first time that bronzes had been used in this way (as against the more traditional portraits, medals, or gold-smith's work), and it was a practice which the Medici were to continue during the succeeding centuries. In this way, while a large bronze *Mercury* was sent to the Emperor Maximilian, a small version was sent to the Saxon court at Dresden, and one of unspecified size to France. The small bronze in Vienna [figure 89] may also have been a gift to the Emperor Rudolf II, and the *Mercury* sent to the Duke of Bavaria may have been by Giambologna though this might possibly have been an antique. In 1603 Ferdinando de

65

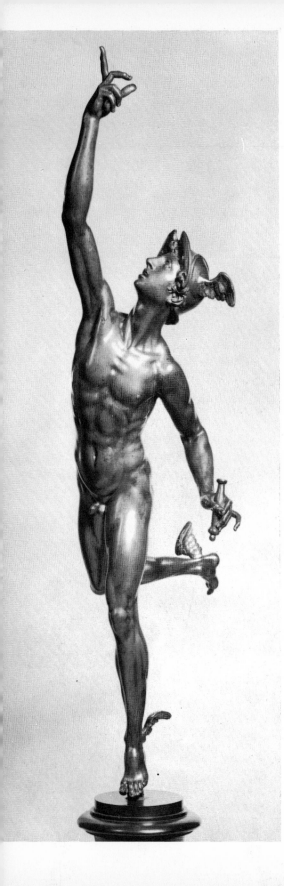

Medici sent a gilt bronze crucifix of Giambologna's design to the Countess of Lemnos in Spain, and when in 1609 Cosimo II sent a silver Crucifix by Giambologna to the Duke of Mantua he added a strongly worded request that he should not have any copy made of it. We know that this was not a casual matter, for such was the veneration for the master's works that, for example, Cosimo Bartoli wrote to Vasari that he had had a horse of unspecified material cast in bronze 'for my pleasure', and Hainhofer described a collection in which he saw a bronze Crucifix by Giambologna side by side with a silver copy, while even within the artist's lifetime his *Mars* was imitated with characteristic freedom by Pietro da Barga.

Not all the works described as by Giovanni Bologna were necessarily from his own hand. Fortuna, who had told how models by the master were cast and finished by assistants, added that most of the bronzes in Florentine private collections were made by three or four such men. The leading craftsman among them was Antonio Susini, and referring to him in a letter, Giambologna say that he 'has just cast from my models many statuettes to send to Germany, which are among the most beautiful things which can be had from my hands', so that evidently the distinction between autograph works and those finished by assistants was considered unimportant, or, at least, was only stressed in the case of the former, such as the Naples *Rape*.

Lists of bronzes which Susini cast from his master's models were circulated among prospective patrons, and Antonio Susini, a strange character possessed of an almost pathological miserliness, would keep his bronzes in a cupboard to be shown to visiting clients, with a distinct preference for foreigners over the native Florentines. A visit to Susini became a part of the regular tourist's round. Perhaps because of Giovanni Bologna's northern origins his works seem to have enjoyed a particular popularity in the Netherlands, judging by the number of times that they appear in those paintings of collectors' cabinets in which the Flemish artists specialised, a frequency exceeded only by the antique among the works of sculpture. While some of these portray recognizable collections, others, such as that by Jan Breughel showing Venus and Cupid in such a cabinet [figure 85], may have been allegorical representations of the sense of sight. In this picture we can recognise the three-figure *Rape, Nessus and Dejanira, A Lion Attacking a Horse, A Lion Attacking a Bull* and *Hercules and Nessus*, all of which appear on Susini's list.

Also on this list is a *Walking Horse*, which may be iden-

89 (*opposite*) Mercury, perhaps the best known of all Giovanni Bologna's bronzes; this model is almost certainly autographed

90 (*below left*) A walking horse signed by Antonio Susini

91 (*below right*) This statuette of Henri IV of France from the workshop of Giovanni Bologna combines the horse and body copied from the statue of Cosimo I, with a removable portrait head

tical with that signed by Antonio Susini in the Victoria and Albert Museum [figure 90], an imitation of that designed by Giambologna for the equestrian monument to the Grand Duke Ferdinando. The followers of Giambologna developed an ingenious system by which horse, rider and head were each cast separately to make small equestrian statuettes with portrait heads to order. So Tacca's *Philip III of Spain* in Kassel uses the horse and body copied from the large *Ferdinando*, while the small *Ferdinando* in the Liechtenstein collection, signed by Giovanni Bologna, is copied from the large monument to his father Cosimo I, as are the *Henri IV of France* in the Wallace Collection [figure 91] and the *Rudolf II of Austria* in Stockholm. A statuette of the *Archduke Leopold Wilhelm of Austria* in Vienna appears in the corner of a painting by Teniers showing the Archduke himself inspecting his collection [figure 77]. Such statuettes were widely distributed, and may have done more than their monumental prototypes to inspire such artists as Hubert Le Sueur in his statue of *Charles I of England* at Charing Cross, and Andreas Schlüter in that of *Friedrich Wilhelm of Prussia* in Berlin.

92 (*right*) The Studiolo of Francesco I in the Palazzo Vecchio, Florenze, with bronzes incorporated into the scheme of decoration

93 (*left*) Venus chastising Cupid, signed and dated by Giovanni Francesco Susini, 1639

94 An engraving from Gori's *Museum Florentinum* of Hercules with the apples of the Hesperides, from which Baccio Bandinelli modelled the statuette illustrated in figure 79

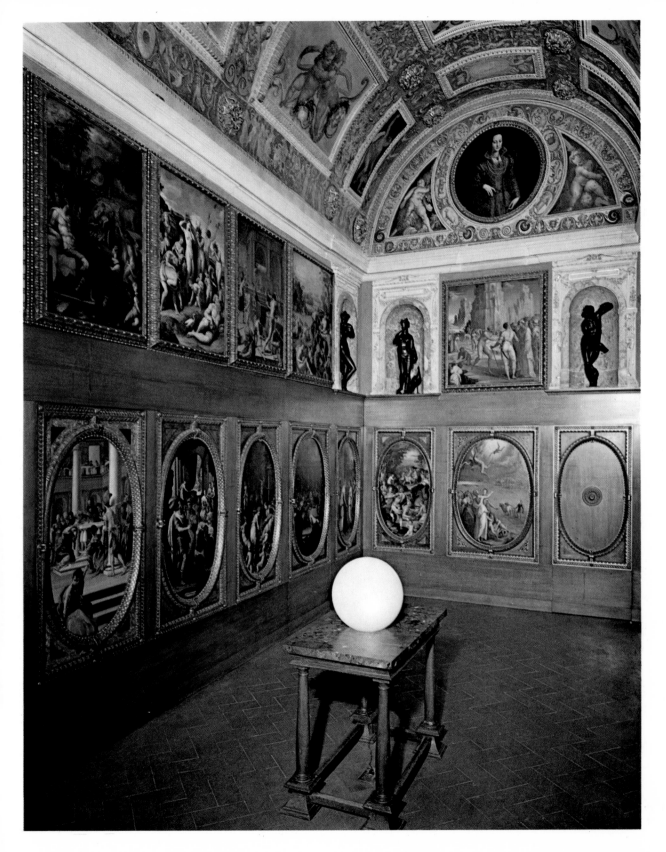

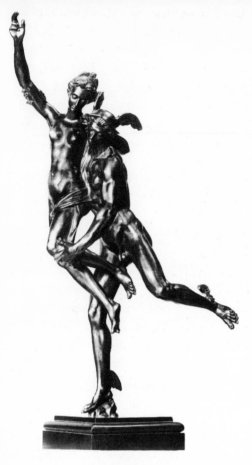

The statuette of *Leopold Wilhelm* is attributed not to Antonio Susini who died in 1624, but to his nephew Giovanni Francesco Susini who lived till 1646, and who inherited the models from his uncle's workshop in which he continued a profitable export trade down to the middle of the seventeenth century. Like his uncle, he also cast copies of the antique, and also his own original sculpture, such as the charming group in figure 94, signed and dated 1639; the motif of Venus using a bunch of roses to beat Cupid, tied to a myrtle tree, goes back to a poem by Ausonius, adapted in the *Adone* of Marino. The style of the *Venus*, while distinctly seventeenth-century, still continues the upward-reaching stance of Giambologna's *Mercury* [figure 89]. One version of this group, dated 1638, with its companion group of *Venus Burning Cupid's Arrows*, had been bought by Duke Karl Eusebius of Liechtenstein before 1658, and another pair now in the Louvre, belonged to the famous garden-designer, Le Nôtre, who left them to Louis XIV.

While Antonio Susini specialised in casting reproductions of his master's work, other pupils spread over Europe, carrying their own versions of Giambologna's style to the service of those dukes and princes for whom the employment of a leading court sculptor had become a matter of prestige. Unlike Susini, these sculptors were not founders, and, like Giovanni Bologna himself, they relied on others to cast their works, but none the less they were fully aware of the potentialities of the small bronze. So the group of *Hercules, Dejanira and Nessus* in Vienna [figure 97] may have been one of the two works in bronze which the Dutchman Hubert Gerhard sent to the Emperor Rudolf II in 1602, or it might be the further proof of his skill in bronze working which he sent in 1605, while negotiating with the Emperor's agent about the possibility of going as sculptor to the Imperial court. Gerhard had fountain in the gardens at Castelli Giambologna made bronzes of birds so life-like that they have been thought to be cast from nature. So too in the Imperial collection we find a series of naturalistic little birds modelled by Caspar Gras [figure 99], a seventeenth-century artist who studied under Hubert Gerhard. Some stand on a branch cast from nature, and seem to sing of a world far removed from the convoluted and elongated figures of court art, the formal portrait and the

95 (*above, left*) The Mercury in this group of Mercury carrying Psyche to Olympus by Adrian de Vries recalls the famous figure by Giovanni Bologna under whom de Vries had worked

96 (*left*) Another interpretation of Mercury by Johan Gregor van der Schardt

dead mythology, to sing of a natural world which could penetrate the court circle only in the bronze image of a bird. already worked for the Fuggers in Augsburg and for the court of Bavaria, and was serving the Archduke Maximilian in Innsbruck. He produced for each of them work which plainly derives from that of Giambologna, just as this excessively frontal group takes up again the problem of welding three figures into a unified whole, but, instead of screwing the figures into one another by their contrary twists as Giambologna had done, Gerhard merely places them side by side, the centaur making an unsatisfactory base, and the embracing arms insufficient to bind them together. Although is has but one view-point, the movements of the figures are at the same time too complex to fit comfortably into one plane.

The Emperor was evidently not impressed, for he declared that Gerhard's work was 'subtle and neat, but the representation somewhat weak', and that 'Master Adrian' did things much better. This was Adrian de Vries, another Netherlandish follower of Giambologna, who was already installed at the Emperor's court. His group of *Mercury and Psyche* [figure 95] demonstrates the extent of his ambition, combining in one bronze the upward-soaring *Mercury* which Giambologna had brought to perfection, with the problem of the two-figure group. Nor can it be said that he has attained complete success. Like Gerhard, he eschews the contrary twists of Giambologna's *Rape*. Psyche rides in triumph, the strong vertical of the group giving it stability, the line from her hand (which once held a jar) to his toe suggesting their rapid movement. But, as so often, de Vries' excessive striving after violent and unusual movement imparts a certain awkwardness to the bronze, which contradicts the idea of flight which Giambologna's *Mercury* had personified.

So potent was the image of this *Mercury* that its influence can be felt on the *Walking God* by Johan Gregor van der Schardt [figure 96], another northern sculptor of much the same generation as Giambologna, who studied in Italy, and then returned to work in Germany. This small bronze in Vienna, like the larger signed version in Stockholm, combines something of the pose of Giambologna's *Mercury* with the less ethereal character of Sansovino's work.

For an artist so closely linked with court circles as was Giovanni Bologna, the refined artificiality of his style might seem in keeping with his patrons' way of life. But some explanation would then be needed for the fashion for genre scenes from the life of the lower orders which is also reflected

97 Hercules, Nessus and Dejanira, modelled by Hubert Gerhard and sent to Vienna as a sample of his skill

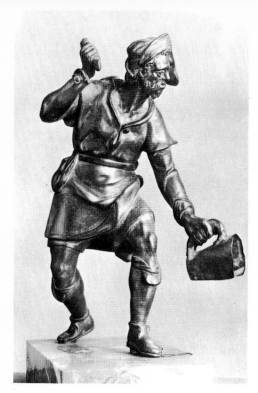

98 A genre figure of a fowler from the workshop of Giovanni Bologna

in his models, such as the two *Fowlers* [figure 95], or the *Bagpiper*. Panofsky has written of a different period that 'it is a truism that a group or class, once made conscious of its own possibilities and limitations, derives vicarious pleasure from the artistic presentation of its opposite'. Here the emphasis should be placed firmly on the word 'artistic', for the complex pose and balance of the *Fowler* has little in common with the boorish German peasant plodding through the mire [figure 75]. But we might go further and see in the very artificiality of court life the need for some reminder of a more natural existence, a sort of equivalent to Marie-Antoinette's dairy. So in the Boboli gardens behind the Pitti Palace one finds a marble statue of a peasant washing her boy's hair in a tub, and another of two urchins playing the popular game of *Saccomazzone*. This marble group by Romolo Ferrucci was carved from a small model by Orazio Mochi, and this model, as Baldinucci tells us, was frequently reproduced in wax, plaster, or metal [figure 86]. Again, for all the naturalness of their movements, the boys have been disinfected and turned into a highly sophisticated work of art.

Naturalness could be taken much further, and for a

99 Even more than fowler or *saccomazzone* group, the bird by Caspar Gras illustrates the strong current of naturalism in early seventeenth-century sculpture

Decline

BY THE SEVENTEENTH CENTURY the character of the small bronze at it had emerged in the Renaissance had suffered a radical change, which was to lead to a steep decline in the following centuries; a decline, that is, as an independent art form, which does not mean that some bronzes of superlative beauty were not still produced.

The causes of this decline were multiple and interacting, and not all were new; the root can be seen already in that tendency towards industrialisation which was present in the

100 A clock with a case symbolizing the town of Avignon, made by Gouthière on the model of Boizot and presented to the Marquis de Rochechouart in 1777

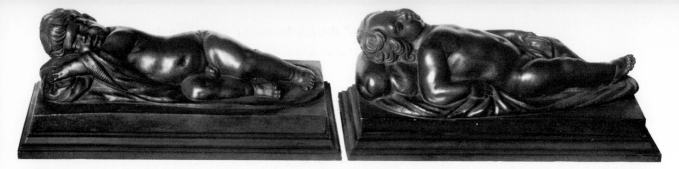

101, 102, 103, 104 (*above and below*) François du Quesnoy's models of babies were greatly admired by collectors and fellow artists

workshop of Giovanni Bologna. One outcome of this was a depreciation of craftsmanship: while the perfection of bronze-casting was a necessary pre-requisite of industrialisation, the separation of the artist who modelled the wax from the founder who cast it, with the degradation of the latter to a menial figure who often did not even sign his work, inevitably altered the whole personality of the small bronze.

With the casting, and often the finishing, of the bronze taken out of his hands, it was not surprising that the sculptor should have had no further interest in those qualities of the statuette which had made it into an original medium of expression, rather than just a convenient means of reproduction. Too often both sculptor and founder lost all feeling for scale, and while the sculptor was pleased to see his monumental works reproduced in small and readily saleable versions, the craftsman would pride himself on the skill with which he could retain on a fussily minute scale that detail which had seemed appropriate to an over-lifesized original.

These factors were encouraged by a prevailing aesthetic theory which saw the genius of an artist in the power of his 'invention', his conception of an idea rather than its execution in paint, stone or bronze. The origins of this theory go back to the ancient division between liberal and mechanical arts, and the struggle of the painter and sculptor to be accepted as liberal artists; but the resulting stress on invention to the

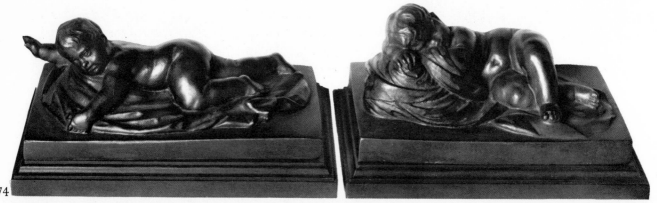

detriment of the mechanics of artistic production weakened both the sculptor's and the public's appreciation of just those qualities which had made each small bronze into an exciting and original creation.

To this depressing general picture there were of course many individual exceptions, bronzes which can rank with the finest of any period. One artist responsible for several such works was François du Quesnoy, a sculptor of Flemish origin who worked in Italy, and, as well as producing two of the finest large statues of the seventeenth century, was widely known for his work on a smaller scale, and in particular for his statuettes of babies [figures 101–4]. His small terra-cotta models were eagerly sought after, and, while probably none of the bronzes were actually cast by his hand, they record accurately enough his understanding of the soft, malleable forms of a baby's flesh, and the charm of its movements. So renowned were these models that an artist such as Albani, himself no mean painter of babies, would hang them in his studio, and the French sculptor Girardon had no less than twenty-six models of children by du Quesnoy in his collection [figure 105], while they have been reproduced in ivory, Wedgwood black basalts, and modern anonymous plaster casts.

Just such a putto is fastening the wings on Mercury's feet in another bronze by du Quesnoy [figure 110], made originally as a pair to an antique *Hercules* in the collection of Vincenzo Giustiniani. Engraved with the antiques from this collection, it found its way into standard works on classical antiquities, but, for all that its pose is derived from the *Antinous*, its structure in the form of a diagonal cross within the three dimensions of the imagined block declares it a work of the seventeenth century, as unambiguously as does Mercury's tender glance, or the chubbiness of the putto.

It was in Florence in about 1600 that the painter Lodovico Cardi, called Cigoli, modelled an anatomical figure which proved so popular that casts in plaster and wax circulated during the artist's life-time, and bronze casts such as that illustrated here [figure 106] were made probably slightly later. Cigoli was deeply interested in scientific matters; he supplied his friend Galileo with information about sun-spots, and painted the *Virgin of the Assumption* standing on a moon with its surface pitted as it had appeared in Galileo's telescope. This *écorché* anatomical figure is the result of the lessons of the French anatomist Théodore de Mayerne. Like the woodcut illustrations to Vesalius, even such utilitarian

105 Detail of an engraving by N. Chevallier of part of the collection of the sculptor Girardon, including several studies of children by du Quesnoy

106 An anatomical figure cast from the model by Cigoli

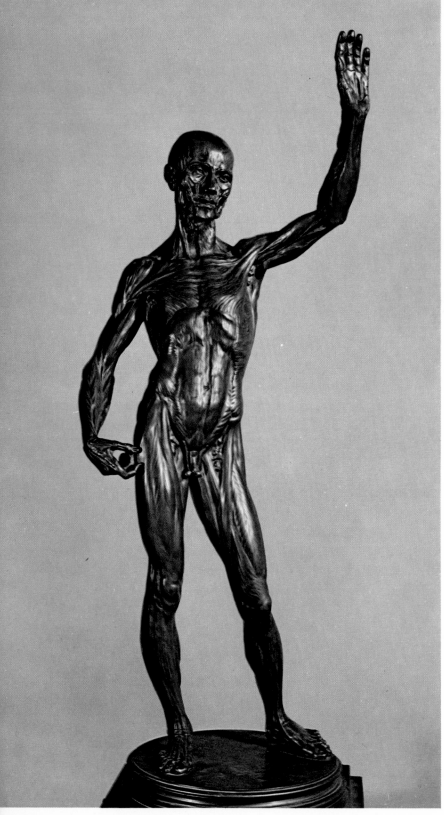

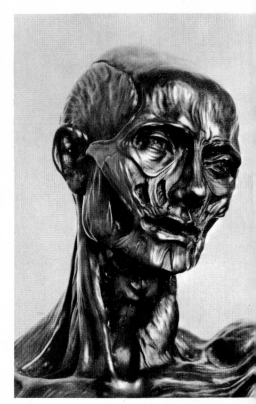

107 A detail of the head of figure 106, showing how even such a primarily utilitarian object could be given a rich sculptural treatment

108 (*right*) This group of Apollo and Marsyas by Giovanni Battista Foggini was sent by Duke Cosimo III to his son-in-law, the Elector Johann Wilhelm von Pfalz-Neuburg, to ensure his support for Tuscany

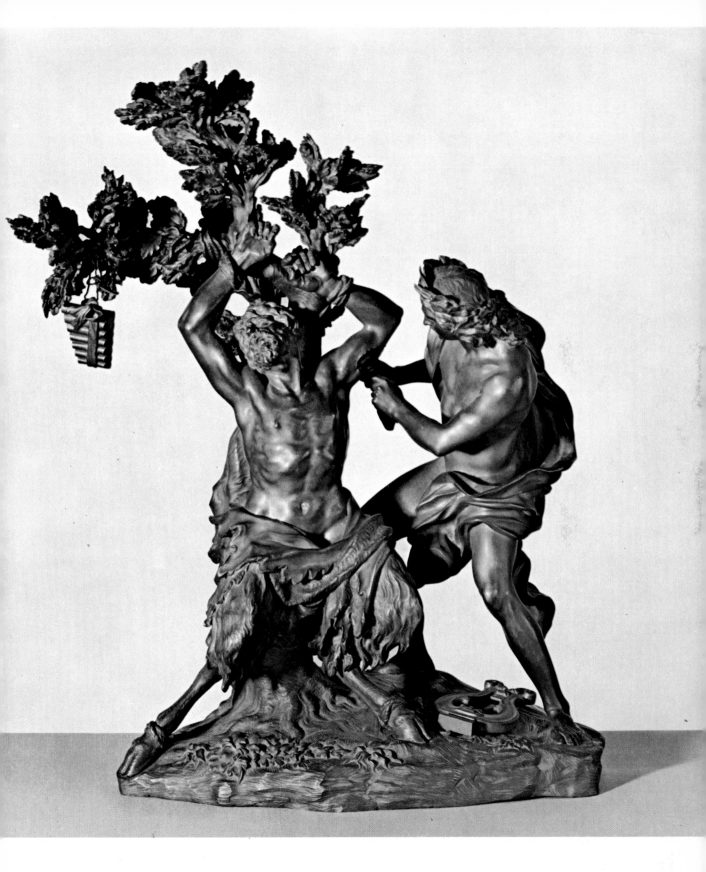

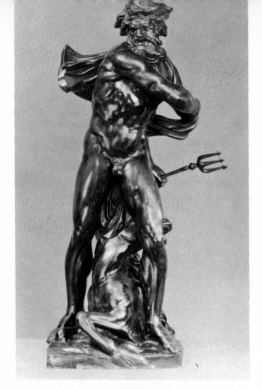

109 Michel Anguier's Neptune, another interpretation of the theme which had inspired two Venetian sculptors (figures 26 and 27)

and diagramatic subjects could be imbued with all the qualities of a work of art; the pose designed to display the anatomy with the greatest clarity takes on a harmony of line, and the deep hollows between the muscles have the romantic quality of some visionary architecture [figure 107].

The studio which Giambologna had occupied in the Borgo Pinti had not remained empty after his death, and the Florentine court had continued to commission small bronzes and to send them out as gifts. Indeed so interested was Cosimo III in his foundry that in 1682 he sent one of his officials round the countries of Western Europe to study and report on their metal working techniques, not only for the making of arms and fortifications, but also for casting sculpture. After the death of Ferdinando Tacca in 1687, Giovanni Battista Foggini took over the Borgo Pinti house, and furnished the Dukes of Tuscany with bronzes. He continued such traditional practices as the designing of an equestrian statuette with a removeable head, and it was he who made the *Apollo and Marsyas* which Cosimo sent to his son-in-law, Johann Wilhelm von Pfalz-Neuburg, Elector of Düsseldorf [figure 108]. This small bronze was intended to play its part in the political manoeuvres by which Cosimo was attempting to strengthen Tuscany in the quarrelsome world of his time; the same model was sent in 1716 to the French portrait painter, Hyacinthe Rigaud, as a return for the self-portrait with which he had enriched the Archduke's gallery. The bronze seems well suited to its quasi-official diplomatic role; it is beautifully made but lacking in any sense of intimacy. This is not just a matter of its size (25 inches), but of the conception of the group, which has none of that compactness which Riccio achieved through his innate understanding of the medium, or which Giambologna sought as a test of his skill; the composition spreads to dominate the space around it, and seems to demand translation into a larger sculpture for a garden or a great hall.

The same might be thought to apply to the *Neptune* of Michel Anguier [figure 109], which probably belongs to a set of six gods and goddesses made originally for the jeweller and collector Montarsis in 1652, most of which were later carved in stone to decorate the park of Versailles. The *Neptune* does not seem to have been thus enlarged, although Desplaces engraved it against a background of cliffs and sea [figure 111]. Even there the figure appears restricted within

110 Amor attaching wings to Mercury's feet, engraved by Claude Mellan after a model by François du Quesnoy

111 An engraving by L. Desplaces of Michel Anguier's Neptune as if it were a life-sized figure in a landscape setting

the bounds of its square base, with that emphasis on the sides and corners of the enclosing form so contrary to the outward-spiralling movement of full baroque sculpture, but typical of the more restrained French taste.

Figure 114 illustrates just such a confusion between garden sculpture and indoor ornament. When Velasquez was in Rome in the jubilee year of 1650 he commissioned four fire-dogs for the Spanish court from Alessandro Algardi. Two, representing *Jupiter* and *Juno*, were from Algardi's own hand, the others were finished after his death in 1654 by pupils working from his models, and all four were shipped to Spain. They were re-discovered in 1931 as part of an ornamental fountain in the gardens of Aranjuez. But the models of *Jupiter* and *Juno* had circulated in wax casts among the connoisseurs of Rome, and the palace of Versailles boasted a pair in silver. These disappeared with the rest of the silver furnishings, but not before bronze versions had been cast from them; a pair from the French royal collection are in the Wallace Collection, and a particularly splendid partly gilt version of the *Jupiter Defeating the Titans* with his fiery thunderbolt is now in the Louvre [figure 112].

Against these small sculptures in monumental style can be set the monumental sculpture reproduced in small-scale versions. Such is the bronze in the collection of Mme Sommier [figure 116] which records the nearly twenty-six feet high statue which Girardon modelled for the Place Vendôme, and which was successfully cast in one piece by Balthasar Keller. Girardon himself modelled at least one small version of this statue, from which most of the surviving small bronzes were no doubt cast. But this was not always the case: Bouchardon's equestrian monument to Louis XV, for example, was reproduced by both Pigalle, who had finished the original after Bouchardon's death, and by Vassé.

Such reductions, made without mechanical aids, and on so vastly different a scale, were bound to introduce variations, and their success would depend on the combined skills of the modeller, founder, and chiseller. Similar skills were required by those artists who catered for the constant demand for copies of the antique, not full-sized bronze casts or marble copies, prohibitively expensive to make and requiring large galleries for their display, but small bronzes which would stand comfortably on a mantelpiece, testifying to a classical education or recalling the Grand Tour. In 1496 Antico had made a replica of the *Marcus Aurelius* for Gian Francesco Gonzaga; early in the seventeenth century Franz Aspruck

cast one for the court in Vienna, and in 1763 Pope Clement XIII gave a version of the same antique to the Elector of Saxony in Dresden, where we also find Filarete's cast of two hundred years before [figure 1]. This eighteenth-century bronze was signed by Giacomo Zoffoli, one of several artists in Rome who specialised in such work. Mostly they were trained as goldsmiths or silversmiths, from which we can assume that, while they may have cast the bronzes, their main task was the cleaning, chiselling, and patinating or gilding of the finished work; indeed we know that in 1773 Vincenzo Pacetti was commissioned to make a small model of the *Flora Farnese* for Zoffoli at a fee of four zecchini [figure 119]. On Giacomo's death in 1785 his studio was taken over by his brother Giovanni, who issued a catalogue of bronzes in about 1795, and there we find the *Flora Farnese* advertised at 18 zecchini, then worth about 9 guineas.

Reductions of the antique were sometimes gilt or partly gilt, but by the later years of the eighteenth century the fashion for a more restrained dark bronze had returned on the wave of Neo-Classicism. Earlier in the eighteenth century the taste had been all for lightness and glitter, and bronze was almost invariably gilt. How artistically perfect the results could be is shown by the *Christ at the Column* [figure 115], signed by the Austrian artist Hagenauer and dated 1756. This was perhaps his first cast sculpture, and later he was to prefer the more easily workable lead statuettes favoured by such artists as Donner. But here the gilding takes an essential place in his conception of the work: formally, the light flowing over the surface heightens the fluidity of the modelling, while the subject gains immeasurably from the light reflected in a radiating glory from the angular, broken figure, His golden Godhead adding an inimitable pathos to the body vainly searching for a foothold on this earth.

But such masterpieces are rare in a period when the small bronze sculpture reached its lowest ebb. The Rococo scheme of decoration demanded colour and light, and ornaments were made in porcelain, shining white or gaily enamelled. A new use was found for bronze among the decorative arts, gilded and known as *ormolu*. Gilt bronze furniture mounts had been popularised in seventeenth-century France when André Charles Boulle had decorated his furniture with a veneer based on an inlay of brass and tortoiseshell, and accented with relief figures and masks in gilt bronze, and the sculptor Domenico Cucci executed the mounts for the con-

112 (*opposite*) The silver version of Alessandro Algardi's firedog with Jupiter overcoming the Titans, made for Versailles, was melted down, but replicas survive

113 (*right*) A French eighteenth-century candlestick inspired by Meissonier's style

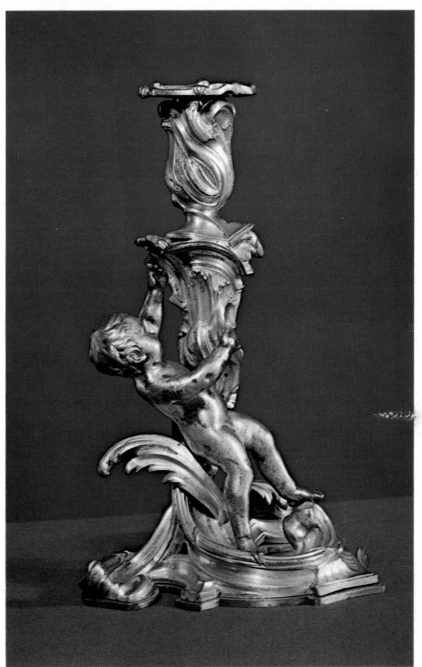

114 A firedog with Juno commanding the winds, from the French royal collection

temporary furniture made at the Gobelins. During the Régence, Cressent frequently covered his fine cabinet-work with a tracery of gilt bronze; later Reissener may have called on the assistance of Gouthière, and Beneman undoubtedly collaborated with Thomire.

These men were craftsmen, often working on designs supplied by others and, like the cabinet makers, organised into guilds. Until 1776, when they were united, there were two such guilds in Paris, the *fondeurs-ciseleurs* who were

115 The emotional qualities of gilt-bronze are exploited in this Christ at the Column by Hagenauer

responsible for those works which were chased and varnished, a cheaper method much in use in France, and the *ciseleurs-doreurs*, who finished those bronzes which received the more expensive mercury gilding. This surface would then be bitten here with acid to create a matt effect (a speciality of Gouthière), and there burnished till it shone like solid gold,

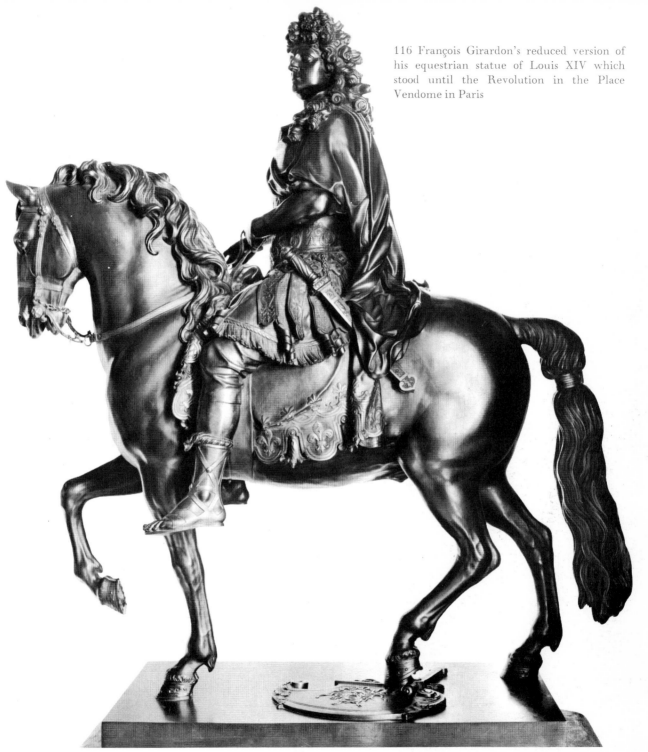

and these craftsmen, few of whom ever signed their work, made French eighteenth-century *ormolu* into the envy of the world.

The Rococo style is typified by Meissonier's engraved design for a candlestick [figure 127]. Dated 1728, it has

83

been hailed as the first work to exhibit this style in its true form, a miniature masterpiece of subtly rhythmic mouldings and ever-varying three-dimensional harmonies. Meissonier himself is not known to have worked in metal, but this design must have inspired the anonymous founder who cast the pair of gilt and silvered candlesticks in the Wallace Collection [figure 113].

Such engravings spread across Europe even more readily than the finished works, and Meissonier's extreme version of the Rococo style had more success abroad than in France. Some of the most imaginatively fantastic Rococo decoration is to be found in the palaces of the Bavarian court, but even before the arrival of artists such as Cuvilliés, Willem de Groff had brought to Munich some of the stylistic elements which in France were to flower in the light-hearted style of the Régence [figure 130].

But it was in France that the finest *ormolu* was produced, works such as the pair of fire-dogs now in Cleveland [figure 120], signed and dated 'Caffiéri 1752', and made for the Château of Saint-Cloud. Jacques Caffiéri was a member of a family of sculptors; his father had worked on the bronze ornaments of the *Galerie des Glaces* at Versailles, and he was himself the leading *ormolu* craftsman of his day. The hound and boar snarl at each other from their heavy gilt scrolls, hair and skin punched to catch the flicker of the fire and shake it dancing back. The same motif of the hunt inspired Pitoin, the favourite bronze worker of Louis XVI, when in 1772 he made a pair of fire-dogs for Madame du Barry [figure 122], topped with a seated boar and an exhausted stag, the smooth-burnished bases ornamented with swags of fruit and game. The composition has become lighter, and the workmanship more delicate, with that profusion of flowers and foliage in which this period delighted.

One of the few *ciseleurs-doreurs* whose name is widely known was Gouthière, the artist to whom the stag and boar fire-dogs had long been falsely attributed until Monsieur Verlet found their true author. But Gouthière did indeed make and sign the case for the clock illustrated in figure 100 from the model of Boizot, as a gift from the city of Avignon to its governor, Jean Louis Royer de Rochechouart. 12,000 livres had been granted by the city council for a clock 'of which the pendulum should symbolise the beating of the Heart of the City and of which the hand should mark no hour which was not distinguished by his beneficence'. In effect Boizot received 1,500 livres and Gouthière 9,200,

117 Study of a hand by Auguste Rodin

84

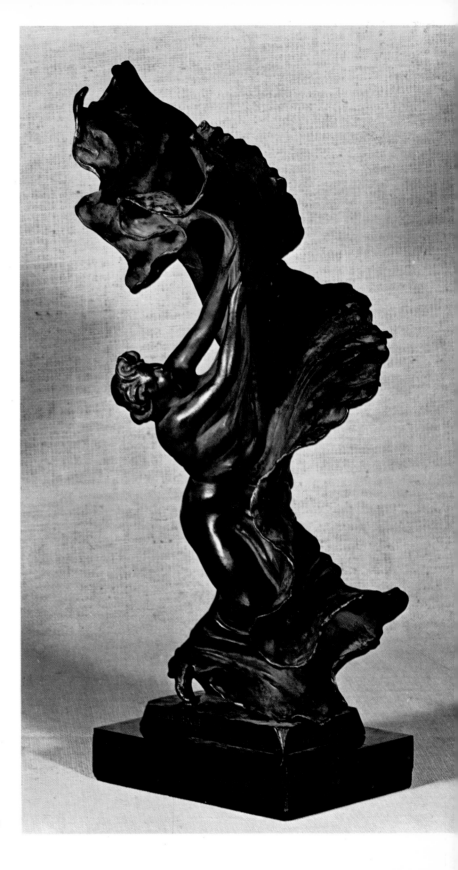

118 Pierre Roche recreated in monochrome bronze the effect of Loïe Fuller's dance, in which she swirled her veils to the accompaniment of changing coloured lights

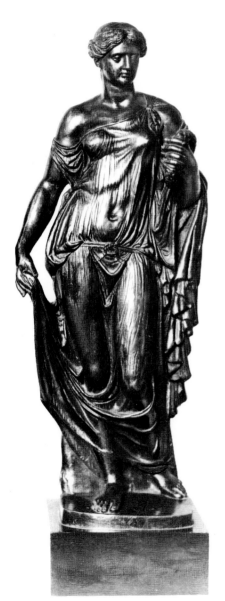

119 A copy of the antique Flora Farnese made by Zoffoli

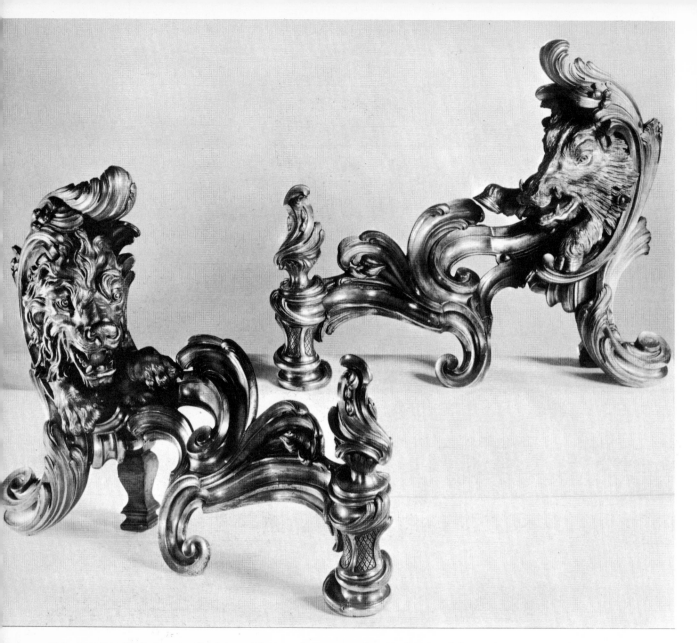

120 A pair of gilt-bronze firedogs with a
hound and boar, which Jacques Caffiéri made
for Saint-Cloud in 1752

between them almost thirty times the 360 livres paid to
Lunezy 'for everything which concerns the clockwork'.

The amount of work involved in these furniture bronzes
and the subdivision of their manufacture into different
processes, each executed by specialised craftsmen, can be
judged from the payments made in 1766 for a pair of fire-
dogs surmounted by recumbent lions, executed for the *Salon
de la Paix* at Versailles [figure 134]. 72 livres were paid to
Bureau, Pigal, and Boureffe for projects in wax and wood,
192 to Boizot for the clay model of the lion, 26 to Michaud
for a plaster cast of the lion ready for founding, 18 to Pigal

for the wooden socle, and 120 to Martin for the ornamentation of this socle in wax and wood; these prepared models were cast by Forestier, for a total of 615 livres 11s. 6d.; the lions then had to be chased by Thomire for 144 livres each and Thomire with Coutelle and Boivin chiselled the decorative parts, some of which were re-cast from those already made, while Mayer modelled the laurel branches, thunderbolts, fleurs-de-lys, and balls below; finally, the whole was gilded by Galle at a cost of 1,078 livres. Lost after the Revolution, these fire-dogs were recently bought by a private collector who presented them to Versailles, their fleurs-de-lys replaced by politically neutral lion masks and their ball-feet missing.

Boizot, the artist who designed these lions and the Avignon clock, was a sculptor of some repute, and even so great an artist as Houdon could collaborate in this minor genre, modelling the candlesticks composed of delightful little *putti* supporting a cannon [figure 123]. This candlestick in the Wallace Collection is a copy of a pair which forms part of a magnificent writing desk celebrating the victory of the

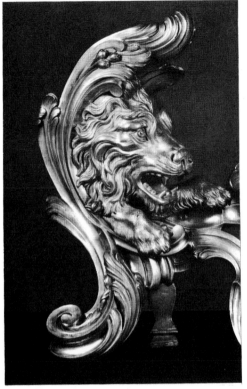

121 A detail of figure 120

122 Firedog with an exhausted stag, made by Pitoin for Madame du Barry in 1772

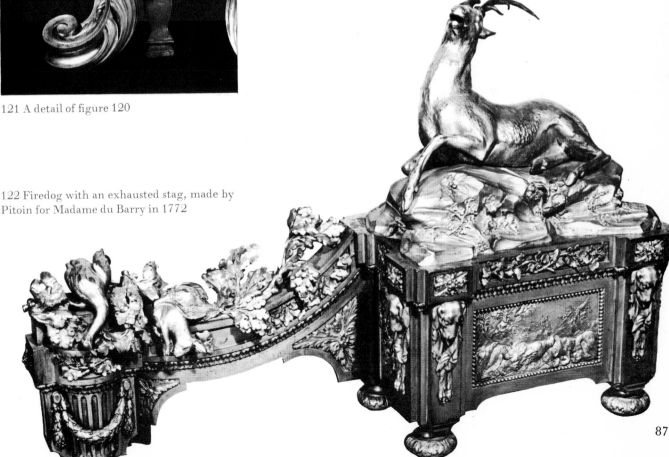

Russians over the Turks in 1741; the idea of an enameller, A. B. de Mailly, it was sent in 1778 through the intermediary of Grimm to the Empress Catherine the Great and stood in the palace of Tschesme.

The uselessness of trying to draw rigid distinctions between fine and applied art is exemplified by the two *Bacchantes* in figure 132, probably designed by Clodion, and each one of a pair: one of them is a work of decorative sculpture, the other is a candlestick. While neither quite recaptures the bloom of Clodion's terra-cottas, that sensation of warm palpitating flesh which only his fingers could impart to the soft clay, the decorative parts such as the ground and tree-stumps provide an object lesson in the tools available to the bronze worker, and the effects he could produce with them. Yet of the two it is perhaps the candlestick which shows the greatest skill in finishing, a softer glow to the flesh, neater engraving, and a more life-giving mastery of the chisels, hammers, files and punches.

These *Bacchantes* show the influence of the more sober Neo-Classic style, with its preference for dark bronze, usually patinated black or dark green and only lightly touched with gold. This style was typical of French taste at the time of the Revolution and under the Empire, a time when furniture bronzes are indissolubly associated with the name of Pierre-Philippe Thomire. His early works were in the manner of Gouthière, though always harder and less subtle than his master's, but his mature style can be judged from the pair of youths with candle-holders in the Rijksmuseum [figure 125]. Coldly modelled, with a dead smooth finish, they lack any hint of personality. We are hardly surprised that, when applying for state aid in 1807, Thomire gave the number of his employees as 211, claiming that in peace-time he would expect to employ 700 to 800 in his factory.

It was not only furniture bronzes which were produced in factories during the nineteenth century. The fashion for porcelain, which had driven out the bronze statuette in the eighteenth century, now acted in a reverse direction, and the popularity of Sèvres biscuit reproductions of models by many leading sculptors revived the interest in artistic statuettes, and gave way in its turn to a revival of bronze, in which Paris took the lead.

These bronzes differed from those discussed so far in that

they were made by sand casting. In this process the shape of the object is impressed into half-moulds of packed sand; for various reasons, including the difficulty of dealing with undercutting, it may be necessary to cast any but the simplest objects in several sections. The fitting together of these sections and the use of half-moulds rather than the single all-enveloping case round the wax of a *cire-perdue* cast are likely to produce rough joints which even the most skilful finishing cannot completely disguise. Moreover, the surface of a sand cast seldom reproduces the same delicate modulations of the original surface which can be retained in the best wax cast. However, sand casting has the overriding advantage of economy, and since a mould can be prepared in just a few hours it is well suited to the industrialised bronze.

Another change in what had been the normal order, at least outside Renaissance Germany, was that is was now the founders, organised into an association of *bronziers* in 1818, who called the tune; often they held the sculptor under contract, and the public was more aware of buying a bronze edited by a founder such as Barbedienne than a model by Barre.

The success of the *bronze d'édition* of the nineteenth century depended on two technical factors: the use of the relatively cheap sand cast, and the invention by Collas in 1839 of a practicable mechanical reducing machine, which could make an accurate copy of a statue in any size. Well might Barbedienne, who made use of this invention, ask rhetorically whether Collas had not done for statuary what Gutenberg had long before done for written thought.

To dismiss these bronzes as works of industry rather than art is to ignore the ambiguous position which the small bronze had always held; Baudelaire's contemptuous 'Caribs of the andiron' could apply to Riccio, who himself adapted the sphinx from the base of the Santo candlestick as a fire-dog, as well as to the nineteenth-century Parisian founder, who could adapt a group to serve as a candle-holder, a table centre, or an ornamental clock-case. Pradier's model of a praying girl was provided with a sick child to exploit the topical interest in the cholera outbreak at Palermo, and even Barye made tortoises as boxes whose shells were the removable lids. But Baudelaire's complaint that 'they would be happy to convert even the tombs of St Denis into cigar- or shawl-boxes', while it could apply in principle to many of the finest bronze makers of the past, does underline the tastelessness which degraded many of the works of his

124 A setter by Pierre Jules Mène

125 Candle-holders in the Empire style by
Pierre Philippe Thomire

126 In his bronze of a tiger devouring a civet Barye brought to this specifically romantic subject of violence his sure grasp of structure and modelling

127 An engraving of a candlestick from a book of designs by Juste Aurèle Meissonier, published in 1728

contemporaries and their passion for period pastiches.

If we forget these *bronzes d'édition* we should lose such charming statuettes as Alfred Barre's *Queen Victoria* [figure 135], a delightful mixture of dignity and grace which the French artist modelled in England in 1837 and which was edited by Dominic Colnaghi. Many of these romantic bronzes, whose history and production have been studied in an unpublished thesis by C. B. Metman, portray the prominent personalities of the era, or illustrate its favourite plays and novels. Other artists specialised in statuettes of animals, following in the footsteps of Barye. Pierre Jules Mène [figure 124], working in the middle years of the century, usually edited his own bronzes, but after his death his models were re-edited by Susse and by Barbedienne, and some were even copied in cast iron with a bronze finish by the Coalbrookdale Company in England.

Bronzes d'édition had one characteristic which was to prove fatal: the editions were unlimited. This meant not only

128 Antoine-Louis Barye's ten-point stag brought down by hounds was cast in 1832 by Honoré Gonon and his two sons in one piece, and required no chiselling

91

that they could easily be over-produced, but, more serious, that they had no value as investments, since if copies of the model of equal value were still being produced, a second-hand bronze would not increase its price. Other causes of decline were the pirate founders who re-cast popular models, often with little care to the finishing, and the less scrupulous founders who cashed in on a flourishing market, using inferior alloys and less skilled chisellers. In competition with bronze, many other substitute substances were employed, not only the traditional plaster and *papier-mâché*, but zinc, plastic wood, plastic ivory, and bronze-dust galvanised onto gutta-percha moulds. The catalogue of the Great Exhibition

129 (*below right*) Statuette of a male nude by Auguste Rodin, presented by the sculptor to Mrs Harold Nicolson (V. Sackville-West) in 1913

130 (*below*) A firedog symbolizing Autumn, made by Willem de Groff, who was one of the first artists to introduce the Rococo style into Bavaria

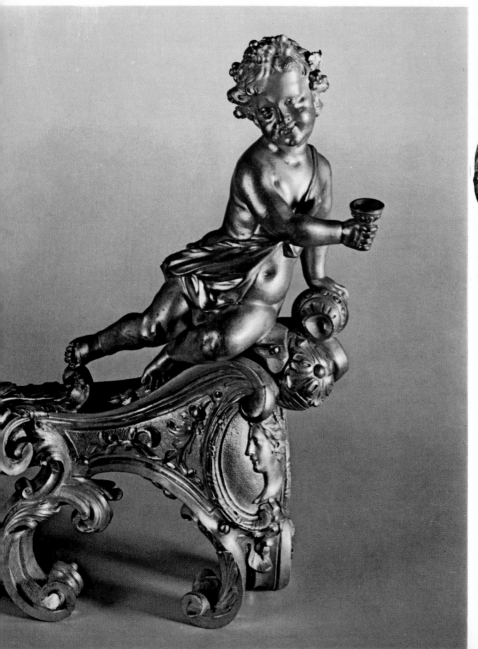

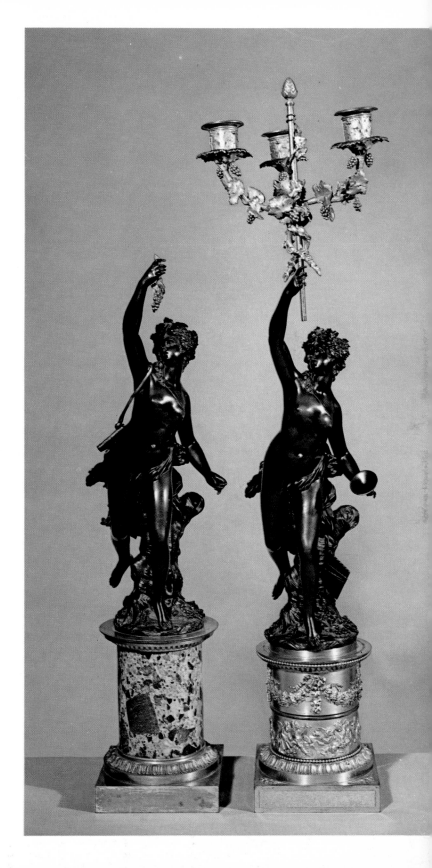

131 (*above*) Honoré Daumier created this statuette of Ratapoil to caricature the spirit of the French Bonapartists of the mid-nineteenth-century, and used him in many of his lithographs

132 (*right*) The same model of a Bacchante by Clodion served for both these bronzes, one of which is purely ornamental, while the other supports three candle-sockets

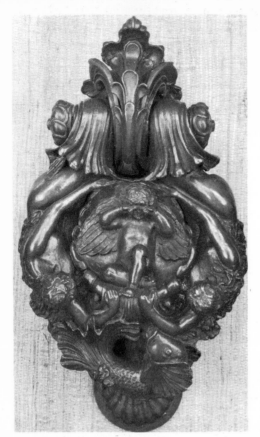

133 A door-knocker made in 1894 by Alfred Ernest Lewis, and at one time mistaken for a late sixteenth-century work

134 The accounts for the making of this fire-dog show how many workmen, apart from the modeller Boizot and the chiseller Thomire were involved in its creation

of 1851 even explains the scarcity of ornamental bronzes by the popularity of such new materials.

If sand casts could sell so well, why bother with the laborious process of *cire-perdue*, where the need to break the mould after each cast was bound to make the cost uncompetitive? Only one artist of consequence did: Antoine Louis Barye. Barye rightly insisted that only this process could preserve the vital surface of his sculpture, and, apart from a period of bankruptcy when his models were cast by Emile Martin, the founding was done either by himself or by Honoré Gonon, an idealist who received regular praise and no financial encouragement for his persistence with this method. Their interest and pride in the technique of casting are illustrated by this work in the Ashmolean [figure 128], which bears besides the signature and date, 'Barye 1832', the triumphant inscription in French: 'cast in one piece without chiselling by Honoré Gonon and his two sons'.

Working in the romantic taste which produced Delacroix's contemporary scenes of animal life and violent death, Barye specialised in the more blood-thirsty activities of the wilder animals, and the most typical works of this sculptor, who never moved further from Paris than the Forest of Fontainebleau, represent one exotic animal tearing another to death. We have only to compare his *Tiger and Civet* [figure 126] with Giambologna's conventionalised *Lion and Bull* to see how he managed to condense the power of the big cats into his small bronzes, and reproduced each quivering muscle in his cast.

The fashion for small bibelots and the revival of interest in the more decorative aspects of the Renaissance style in the latter years of the nineteenth century gave an added incentive to the collecting of Renaissance bronzes. Encouraged by the growth of scholarship on this subject, particularly in Germany, wealthy industrialists and bankers began to bid high prices for them, and, inevitably, there were many forgers to take advantage of this. It would be unjust to class Alfred Ernest Lewis with these, just because the signature 'A. E. LEWIS' on his door-knocker [figure 133] was misread as the Italian 'LEVVIS', and the date of '94' taken to mean 1594. This is probably the bronze knocker which this graduate of the Royal Academy schools showed in the Academy exhibition of 1894, and, though it is obviously inspired by Renaissance works such as figure 55, there is no attempt to disguise the sinuous curves so characteristic of Art Nouveau.

This movement can be seen in a purer form in *Loïe Fuller* by Pierre Roche [figure 118], made about 1900. The famous dancer whose swirling veils inspired so many artists, among them Toulouse Lautrec, here approaches that typical Art Nouveau ideal, the dance without a dancer, the drapery swirling upwards in metaphorical allusion to flames and serpents and unfolding flowers.

Roche was a pupil of Rodin, who himself produced some of the most beautiful bronzes of the late nineteenth century. Absorbed in the problems of movements and gesture, he fired off a succession of small clay sketches, seizing the exact turn of the model before it could freeze into a conventionalised pose. The rough surface, the traces left by his sensitive fingers, are essential to his art, but to reproduce such details in bronze calls for the finest craftsmanship on the part of the founder. Rodin's clay original would be cast in plaster, from this the wax would be prepared and, at least in his more important work, retouched by the artist himself. A comparison between Alexis Rudier's bronze cast [figure 137] and the plaster also in the Musée Rodin should remind us of the tact with which the founder has interpreted Rodin's thought.

Rodin may have known the busts and figurines which Daumier had modelled to serve as prototypes for his lithographic caricatures. Most of these were left in painted but unfired clay, though *Ratapoil* [figure 131], created in 1850 as the arrogant but threadbare embodiment of the Bonapartist revival, was cast in plaster for Daumier's own use. The first bronzes were not cast till 1890, eleven years after Daumier's death, when familiarity with sculpture such as that of Rodin had accustomed people to bronzes in which the filing, chasing and polishing were subservient to the aim of reproducing the artist's clay as exactly as possible in a more durable medium. In fact, the shining surface of the bronze does contribute something to Daumier's work, for the reflections and highlights deepen the contrast of light and shade, and create that effect of uncertain contours which is so typical of his drawings, in which a quivering network of lines suggest the infinite potentialities of constantly changing expressions, a visual transcription of living movement.

Degas was another draughtsman whose sculptures have been recognised as equal in quality to his paintings and drawings, though he only once exhibited a model, and that in wax. He recreated in his sculpture those unexpected and wholly natural movements which had fascinated him all his life. A figure such as the *Dancer Examining the Sole of her*

135 Alfred Barre modelled this statuette of Queen Victoria in England in 1837

Right Foot [figure 136], a late work modelled about 1910–11, is not merely a three-dimensional study of a complicated pose, nor an evocation of the dancer's life seen from the wings, the angle of the working dancer rather than the entranced spectator whose emotions were transcribed by Roche [figure 118], it is a perfect essay in sculptural balance, in the swing of a heavy body on a single leg, in awkwardness transfigured by art.

But is it a bronze in the sense in which we have been using this term? Degas made his models by the most gimcrack means, and of about 150 found after his death, many were total wrecks, and others had to be repaired before they could be cast by Hébrard. Comparison with the wax original can only strengthen our recognition of the skill with which the founder has gone about his task, even patinating the bronze so as to recapture the variegated colours of the wax. But it is surely significant that of the three nineteenth-century artists whose bronzes are most admired today, two never intended the bronzes we know to be cast at all. Our admiration goes to them as works of modelling; the medium has been selected only for its durability, and has been treated so as to approach as nearly as possible to some other medium, wax or clay. We demand from our founders skills as great as ever before, but when these skills are devoted to the characterless reproduction of other materials, then the small bronze is surely dead.

136 After Degas' death a number of wax models were found in his studio. The dancer examining the sole of her right foot was among those salvaged and cast by Hébrard

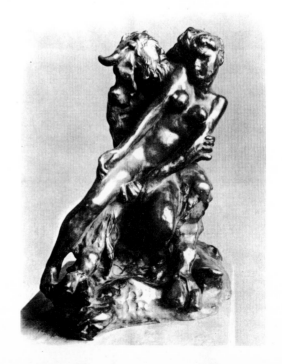

137 Rodin's Minotaur of 1885 was cast by Alexis Rudier, whose skill could translate the subtleties of Rodin's modelling into bronze